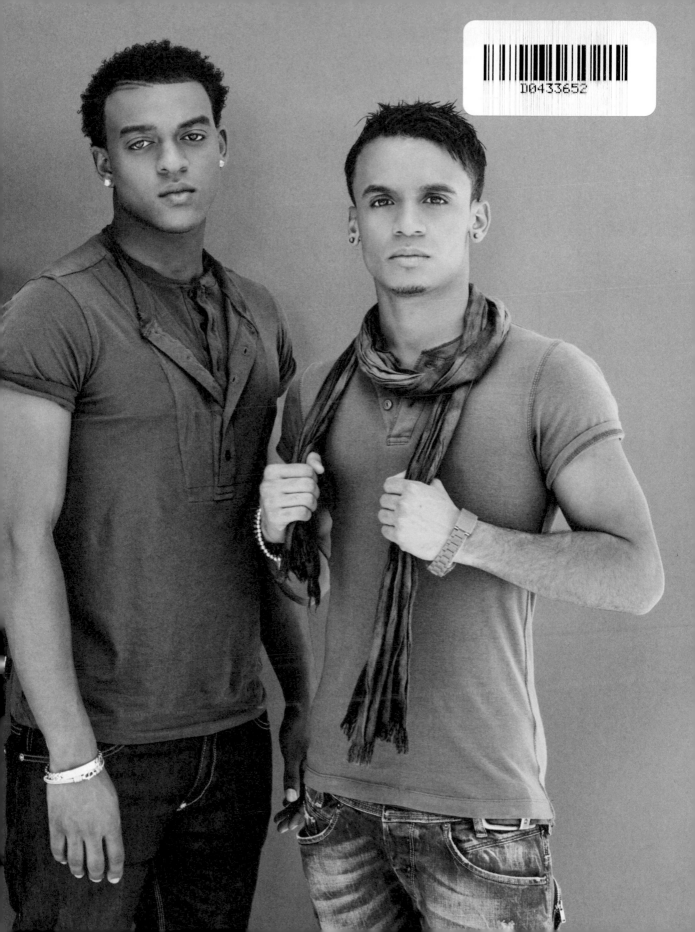

Hi, we're JLS and we're thrilled to present our very first book! It's your introduction to us as a band and to each individual member, and it's packed with group photos and portraits that show us working, relaxing and meeting our fans, amongst other things. As you can see, we're all really enjoying life right now!

There's a section from each of us, in which we tell you about ourselves and talk about our personal journeys from aspiring singers and songwriters to *X Factor* finalists; how we bonded as friends and performers; and how we made it through the ups and downs until finally being signed to a record label and becoming performers in our own right.

We hope you like this book as much as we do! We had a brilliant time putting it together and we're very excited about it. Hopefully it's the first of many, because we're planning to be around for a long time. Happy reading!

Lots of love,

ORITSÉ MARVIN ASTON JB

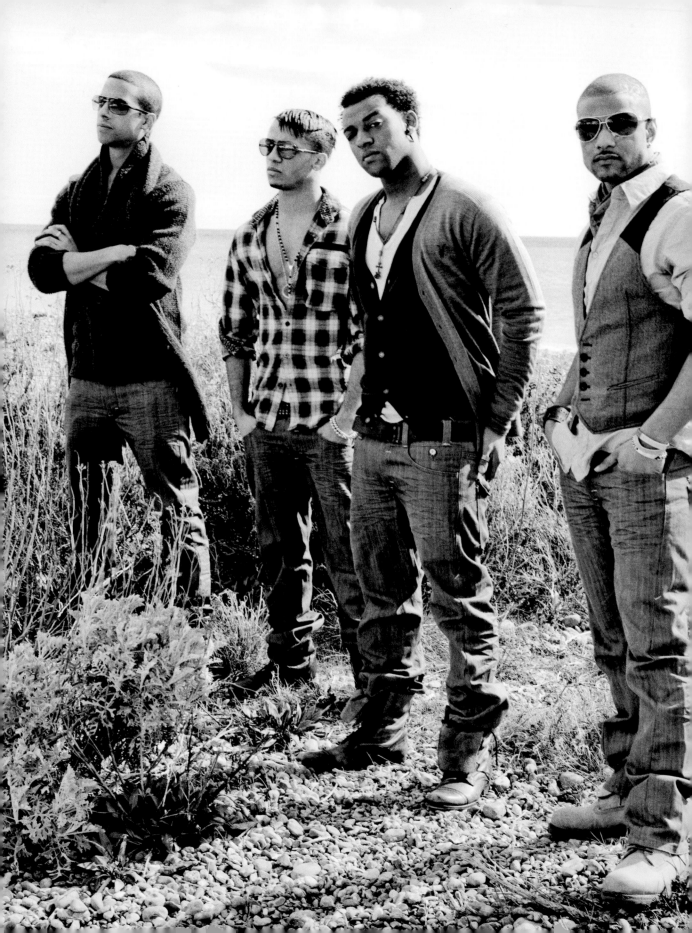

OUR STORY SO FAR

Photography and creative direction by

DEAN FREEMAN

HarperCollins*Publishers*

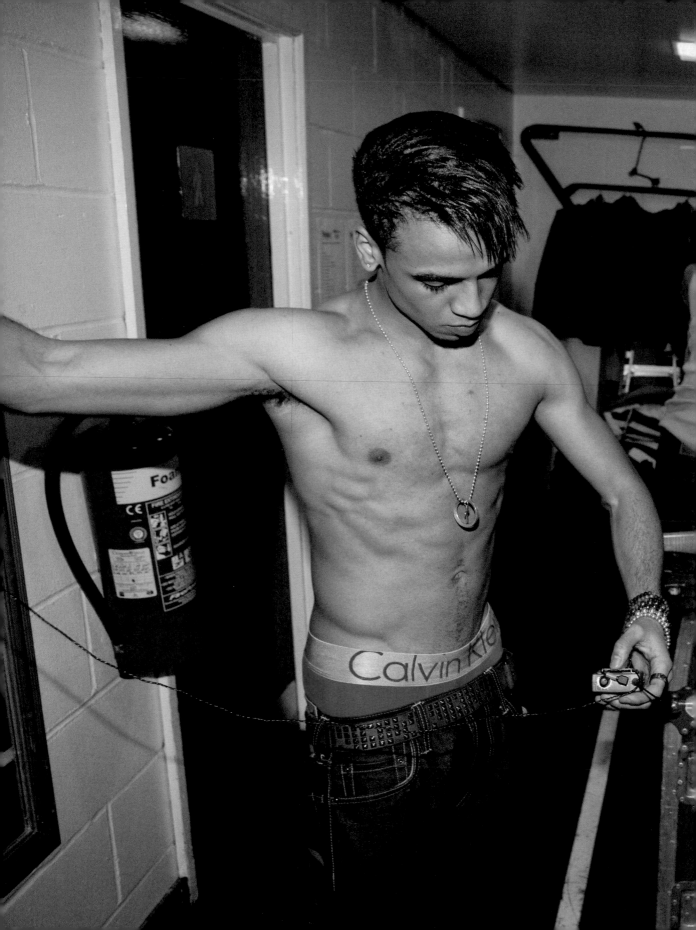

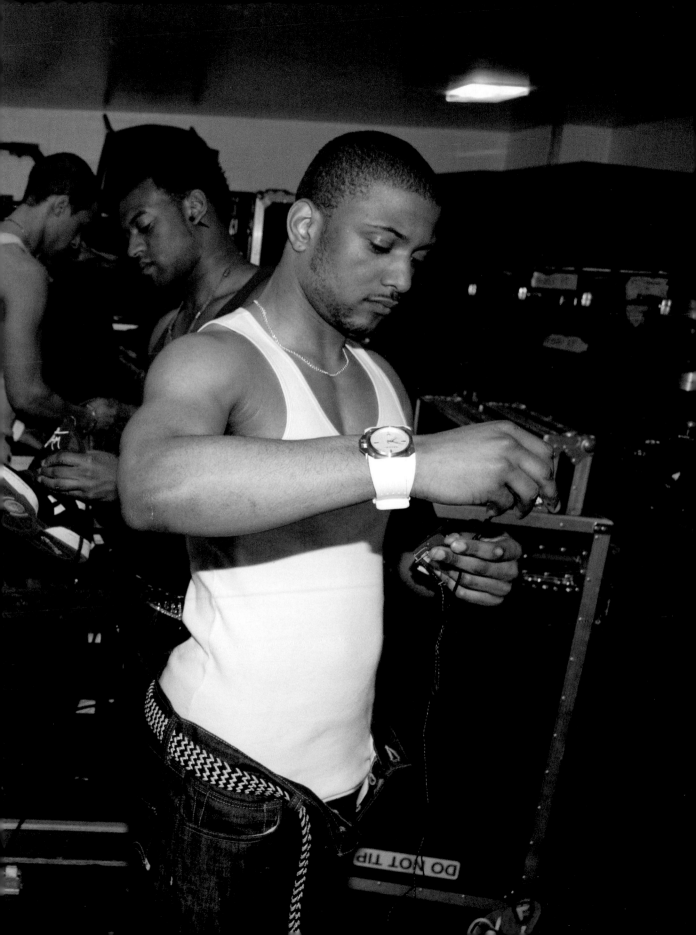

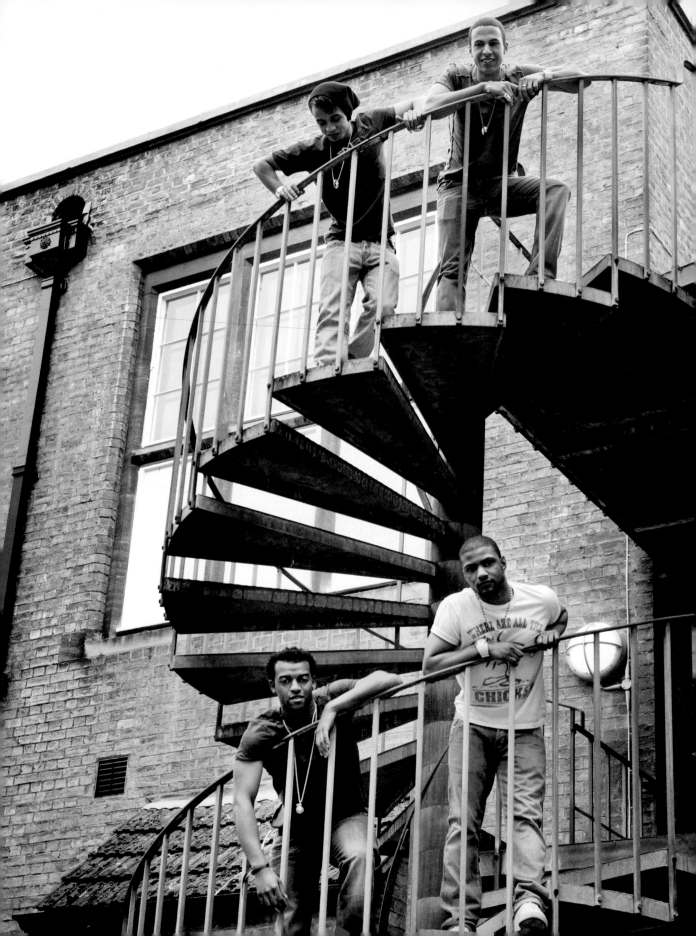

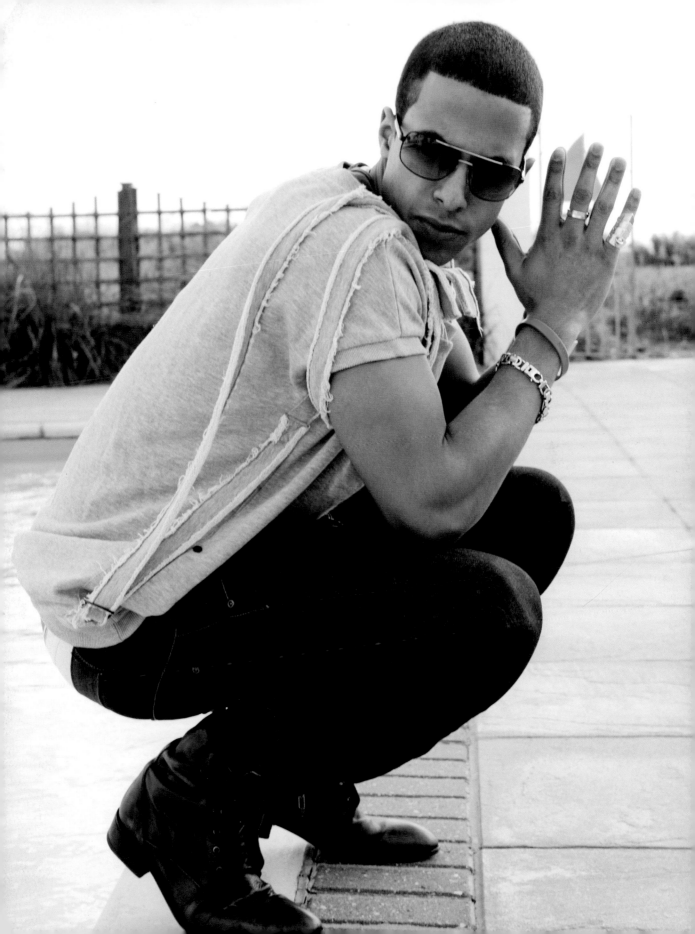

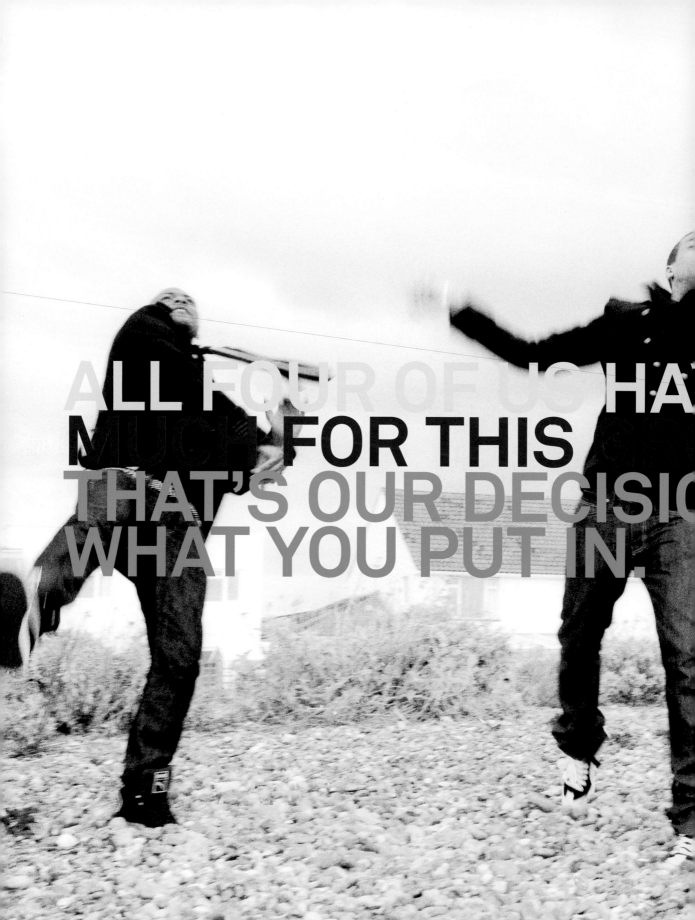

ALL FOUR OF US HA~
MUCH FOR THIS GR~
THAT'S OUR DECISIO~
WHAT YOU PUT IN.

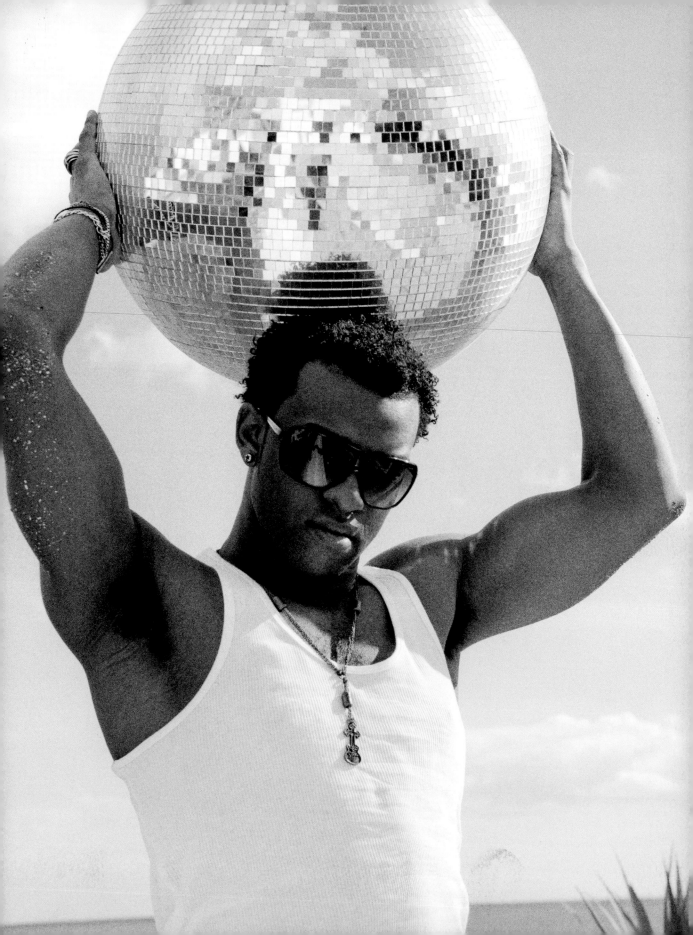

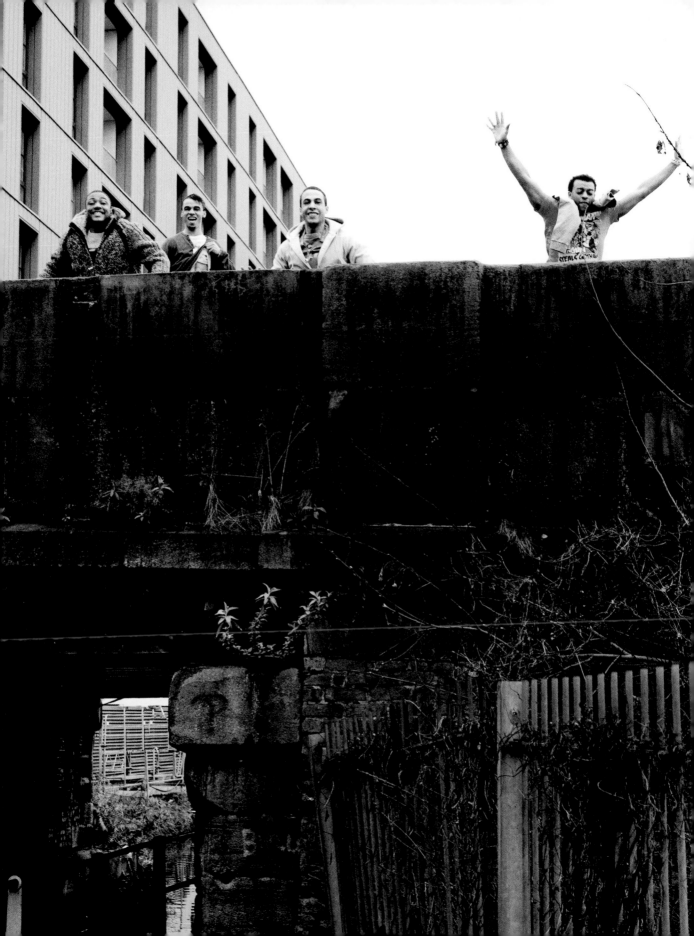

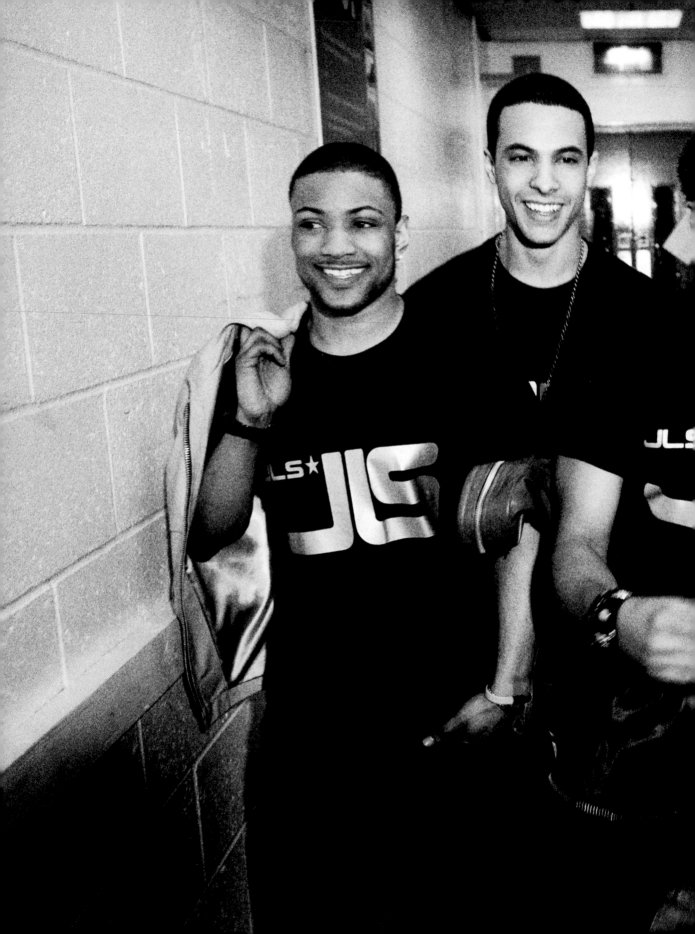

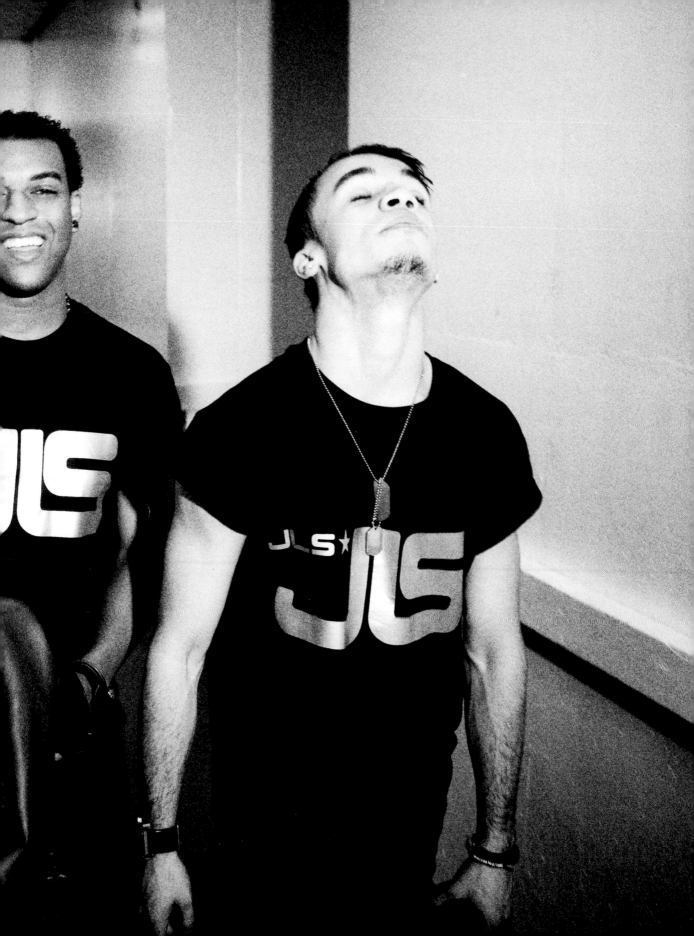

I revisited the idea for a boy band partly because of my mum. She was becoming more and more unwell and every night I used to sit at home, thinking to myself that music could be a way out of our predicament. A big part of my dream is to give her a better environment. I had to work something out.

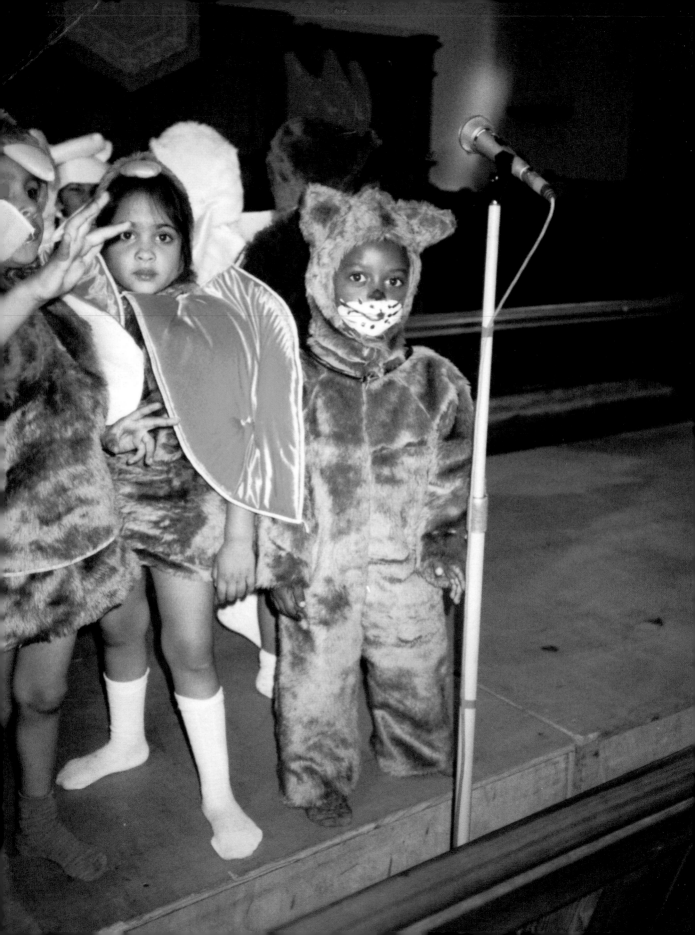

ORITSÉ WILLIAMS

AGE: 22 / DATE OF BIRTH: 27 NOVEMBER 1986 / STAR SIGN: SAGITTARIUS

I'm a very interesting, quirky, fun-loving person – apparently. Well, that's what my friends say, anyway. I wrote my first song when I was ten, so I've been writing songs for a very long time!

My name means 'you are universally blessed' and it comes from a tribe in Nigeria; however my family are originally from the Caribbean. I like my name but people never get it right – it's always been a problem. No one spells it right: the papers are the worst.

I spent two years in Nigeria between the ages of sixteen and eighteen; a family member was working in Lagos and I decided to take the opportunity to go over there and experience life in a different country.

The idea of taking the conventional route from school to college bored me and I was looking for new experiences. I wanted something more vibrant and exciting in my life. I had issues at my school in England, just because I was very outspoken and the teachers tended not to like it. I went to a very good school; it was one of the best state schools in London.

Everyone was planning to go to sixth form college, but I felt that my best interests lay elsewhere. Everything changed for me when I walked into the careers advice office and said, 'I want to be a singer, a musician.'

OPPOSITE: ME AS THE GRIZZLY BEAR IN MY PRE-SCHOOL ASSEMBLY, BAMBOOZLED AS THE MICROPHONE WAS TOO HIGH FOR ME TO SING, HAHA!

'Forget it,' I was told. 'Think about something else, like catering.' That was what really turned me to drastic action.

I got reasonable GCSEs; I could have worked harder, but I was always distracted by music. In my exams I'd be writing songs. Nobody could understand it. I kept on saying to my mum and my teachers, 'I don't understand why I'm so distracted by music. I don't know what it is; it's almost like a drug, I can't help it.'

The school got really fed up with me. It was very traditional and there was also no way that I could hone my talent and my musicality. The best way I could work on my creativity was through English Literature and English Language. English was the subject that got me through the whole of my school career. My favourite works are by the metaphysical poets, like John Donne.

I fell in love when I was fifteen. I don't know if it was puppy love, but the moment I saw her, I started feeling something I'd never felt before. It was weird. My insides collapsed! I chased her, asking her out all the time. Looking back, I don't know if she was interested or not; perhaps she was just leading me on. If so, she led me on for a very long time. I was so infatuated with her that when I went to Nigeria I didn't even look for a girlfriend.

When I came back, I still wanted to be with her. I sent her flowers, I did big things for her birthday and I always sent her stuff, even though I had no money. Everybody said I was a fool. 'Just let go,' they said. 'Don't go there any more.'

Then I met a girl who helped me get over her, but I still thought about her and I ended up by myself again. I think the attraction was that she was different from every other girl in my social circle. She was intelligent, she was beautiful, she was confident, she had a great attitude and there was always a sparkle in her eyes. I loved the fact that she could really hold her own; I could see myself being with her for a long time.

I made friends in Nigeria, but I was often alone, literally by myself. It was the loneliest time of my life. I used to sit alone in my hostel room for hours, until the boredom became so extreme that I began to feel I was losing myself. So I picked up my guitar and, although I couldn't really play guitar, I plucked away and wrote songs from chords. I wrote, wrote, wrote and sang, sang, sang: that's all I did.

Lagos is a very crazy place and I had a few life-threatening experiences there, so I learned to survive during that time. It wasn't easy being a foreigner, but I made it through. My mum was concerned about me being there and my grandma was even more concerned. Everybody around me was concerned; everybody was scared for me.

But I was looking for adventure; I wanted to go and see where the real singers were and I ended up mixing with some of the greatest singers and musicians that I've ever heard in my life. I went through the shantytowns with my guitar and jammed with some really fantastic people.

I recorded my first song in a friend's little home studio, managed to blag my way into a radio station called Cool FM and persuaded them to play it on the radio. After that it got quite a bit of radio play and all my friends from school heard it, which was amazing.

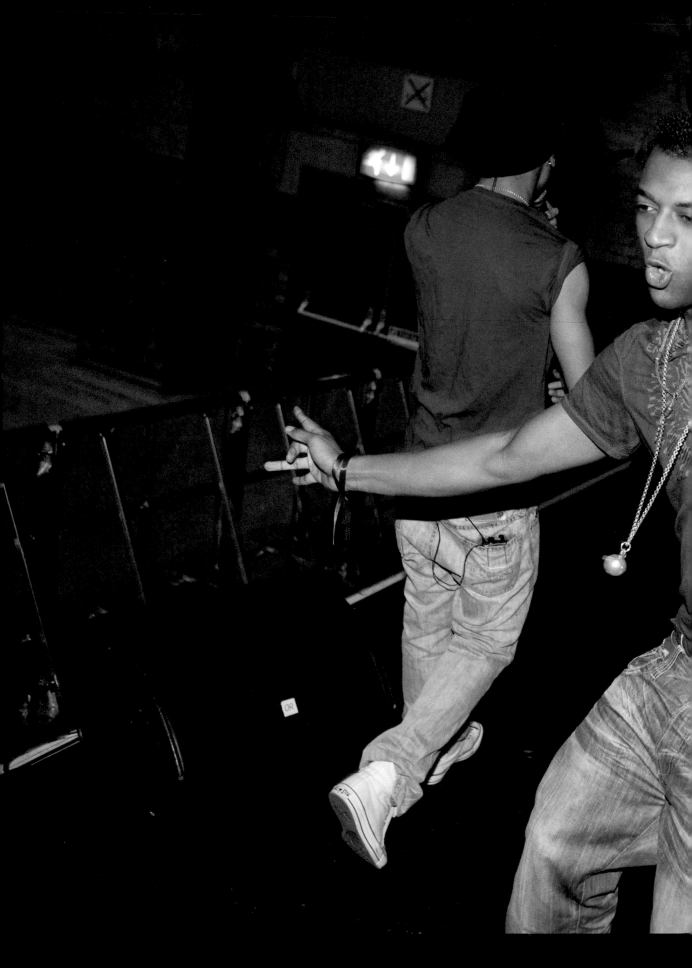

The boredom became so extreme that I began to feel I was losing myself. So I picked up my guitar and, although I couldn't really play guitar, I plucked away and wrote songs from chords. I wrote, wrote, wrote and sang, sang, sang: that's all I did.

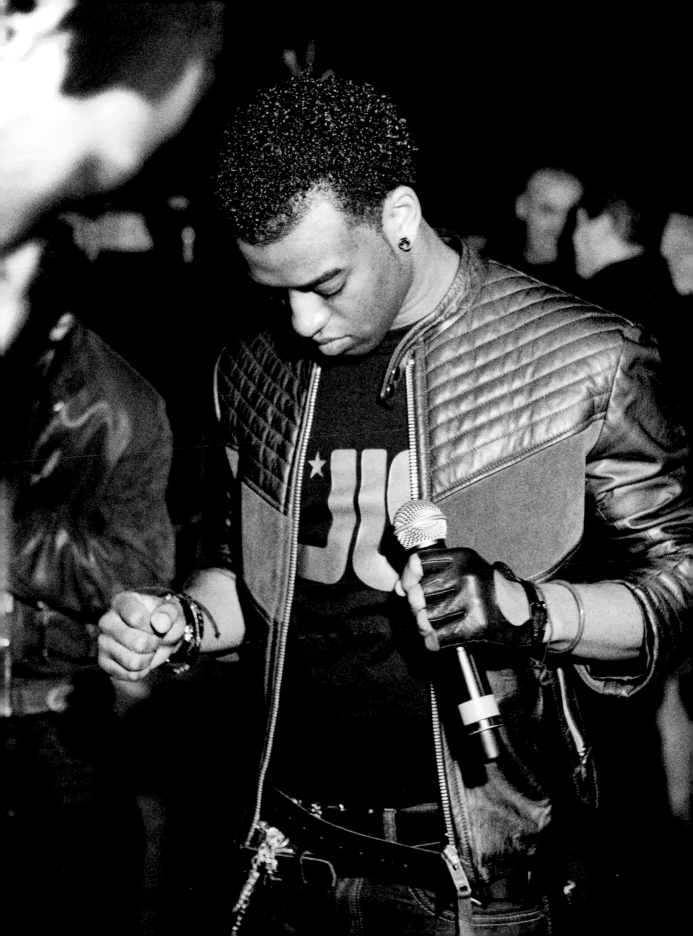

details and his phone number and I checked him out. My first thought was, Wow, he really complements me physically. I just need to check out his vocals.

Straight away it was obvious that JB had the right attitude. I could see he was very determined, just like me. He had this great falsetto and his harmony ability was just amazing. He is the king of harmonies.

I said to the boys, 'Jump in this car with me and I promise I'll take you to the moon. I promise that I won't let you down.' I also assured all their families that we were going to be successful, no matter what.

There was a real vibe the first time we all sang together. Marvin turned to me and said, 'Well done, the band is definitely complete.' We started rehearsing straight away. What was fantastic was that we didn't just get along from a musical perspective; we also got along outside of music, because we liked the same things, we liked the same music, we liked the same movies and we liked the same sports.

JB and I share a rugby background; Aston and Marvin share a football background; Aston and I have an athletics background; we all like R&B, pop and soul. I think my music tastes are a bit more out there, because I love rock too. I love Lenny Kravitz – he's an idol of mine – but I also love Stevie Wonder and Tina Turner.

We began to dedicate ourselves to the band and make sacrifices for it. Marvin started to slow down with his work. Aston was struggling with jobs. I still needed to bring money in, because there were many times when my mum needed money. So I gave out the *London Paper* during the day and worked long nights in the West End, hustling for clubs till three

o'clock in the morning. I'd get paid at four and then I'd go off to sing with the buskers at Piccadilly Circus until the sun rose. I often walked part of the way home, because the night buses didn't go all the way to where I lived. Sometimes it was pouring with rain, it was dark and cold, there were thugs in the street and I had cash in my pocket, so I'd walk along very cautiously. I've seen the vultures come out at night.

I was determined to make it in music, no matter what happened. My passion and desire lies in music and in singing and in songwriting, in creativity and creative thinking and creative writing. When I do those things, that's when I feel alive.

I have goals and I'm obsessed by the objectives I want to achieve, but I also have my silly moments. When I'm most silly is when I'm around my friends and we do stupid things like dancing in the middle of the road in the middle of the night, or when we end up singing and dancing with the buskers in central London until the early hours of the morning. It's usually when I'm with my friends that I get really stupid.

As for girls, a dream date would be to fly to the Caribbean on separate planes and meet each other on a beach in the evening. On this beach there would be a table laden with beautiful fruit cocktails and lovely seafood. A more practical date would be going to a live Latin music night to have a little wiggle. I try to salsa but I'm terrible at it. I'm still working on it!

Girls and guys are definitely equal, but different. I believe in equality in every relationship. I don't believe that guys should dominate women or that women should overrule guys. There should be a mutual connection, give and take. We're all human beings.

OVERLEAF: MY MUM PUT ME IN THIS, SHE LOVED THIS OUTFIT FOR ME, LITTLE SANTA CLAUS, SO EMBARRASSING, 'LOVE YOU MUMMY!'

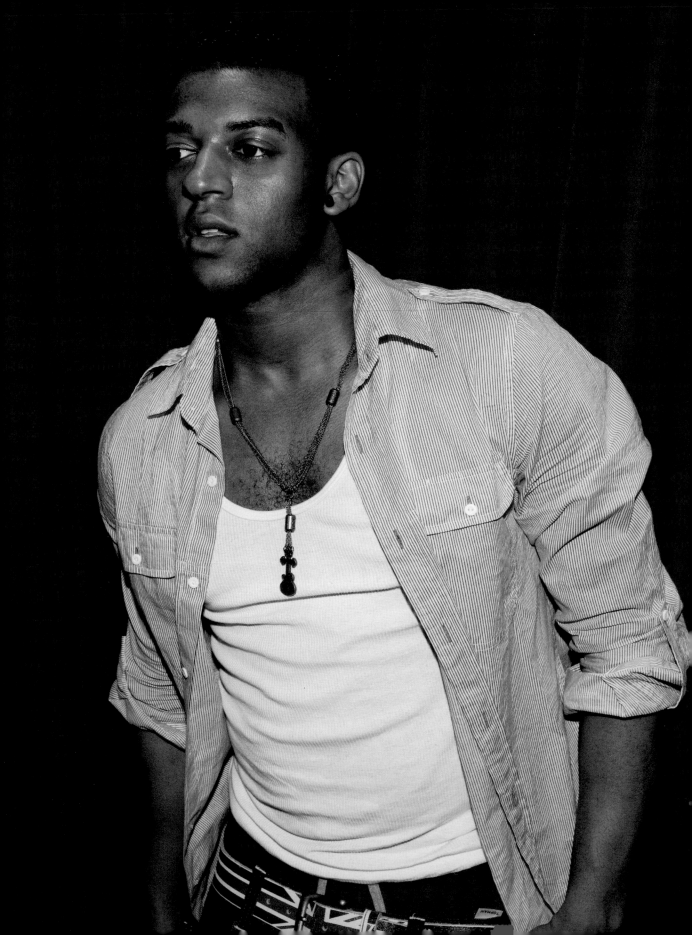

My name means 'you are universally blessed.'

If I took a girl out on a first date and she offered to pay, or pay half, I wouldn't want to accept because I'm a gentleman. But if she were insistent, I would give in. I'd say, 'If you do become my lady, then I'll pay next time.'

If I had no money and she wanted to pay for me? That's happened to me, in fact – I'm not going to lie – and I had no shame in accepting. On one of my first dates, the girl paid for everything. At first, I said, 'I can't accept this!' But she said, 'Don't worry about it.' It didn't make me feel bad, because she was older, had more money and was in a different place in her life. I was a student and she was in music.

When I advertised for a supergroup, I was thinking about how it would be if I took a member of each of the greatest boy bands that have ever been and put them in one band. So, rather than modelling the band on one group, I modelled the band on many groups. And in a way you could say that we've got the 'N Sync in Aston, the Backstreet Boys in Marvin, New Edition in JB, Boyz II Men and Jodeci in me, and The Temptations and Jackson Five in all of us.

I keep things very innovative and I don't settle for the easy option. I'm always looking for the best for us, always looking for better, and I believe that we can be great, not just good. I constantly encourage everybody to do their best and to sing their best.

I believe in the ethos of treating people the way you want to be treated. I believe in a higher power, whether it's the universe or God or whatever you want to call it. Red is my colour because it's passionate, powerful and it's strong. Red is a little bit dangerous. My mantra is, 'From victory to victory.'

The night before our first *X Factor* audition with the judges, I couldn't sing because I was really ill. I was so scared. I had some kind of flu that blocked my throat and I literally could not sing a note. I was actually thinking about giving my part to somebody else, but then I thought, 'You know what, Oritsé? Just be determined and don't think about being sick. Just pretend you're 100 per cent fine, give it your best and you'll get through it.'

It was nerve-racking waiting to go in. There's no turning back now, I thought. It was make or break. Yes or no.

Marvin never usually gets nervous but he was really nervous then. It's the most nervous I've ever seen Marvin. We walked in and I looked at the judges and thought, I am not going back: I am only going forward from here; my whole life will change in this moment. We're only going forward and we're going to get through this, because we've worked too hard and we've sacrificed too much not to.

After the audition, Simon Cowell said, 'You, particularly, have a great voice.' Wow, I thought. It was so amazing to be acknowledged, especially as I'd been so sick the night before.

When we watched the audition on TV, there was a clip of Simon saying, 'These guys are potential winners.' That's when I realised that we were in with a good chance. Wow, I thought. We might just make it.

The first live show was very tense. I remember we were singing Boyz II Men's 'I'll Make Love To You' and Boyz II Men are a huge inspiration to me. I couldn't help but think, 'Oh my God, we're going to get on the stage and we're really going to have to deliver.'

had already thought about being a postman before the show, because you walk a lot, so you get exercise, and it's early morning shifts. But our management said, 'Don't worry. Wait, wait.'

Soon we regrouped and called the management for a meeting. We were ready to have a go at them and say, 'What's happening with our careers? Tell us something! What's going on? We need a deal.'

They came in very smoothly and very subtly dropped the news that we had a record deal. 'We think we've found the right people for you – Epic Records.' For us it couldn't have been any better. It was amazing.

Being on the road with Lemar was fantastic, apart from having to eat at service stations all the time! I've put on about a stone, I think. I eat a lot of good food, but my metabolism is terrible and I put on weight very easily.

A few weeks after putting the band together, I was training diligently, every single day. That routine has been broken now, because our schedule has become so hectic. But while we're putting the album together, I want to get straight back into training. It will make me feel good. I used to train with my friends and I miss them massively. They're very supportive and they love the fact that I'm doing exactly what I said I would do. But I didn't think about the consequences of doing it; I didn't think that I wouldn't have so much time to be with my friends. They understand, though. They're very good friends.

Recording the single was brilliant. With music there are so many possibilities and so much that you can do, but when you only have a short space of time and you have to get something out quickly, you just have to get it done to the best of your ability.

X Factor will always be a part of us because that's what's made us. But now, in order to sustain a career, it has to be about JLS and about the music that we release.

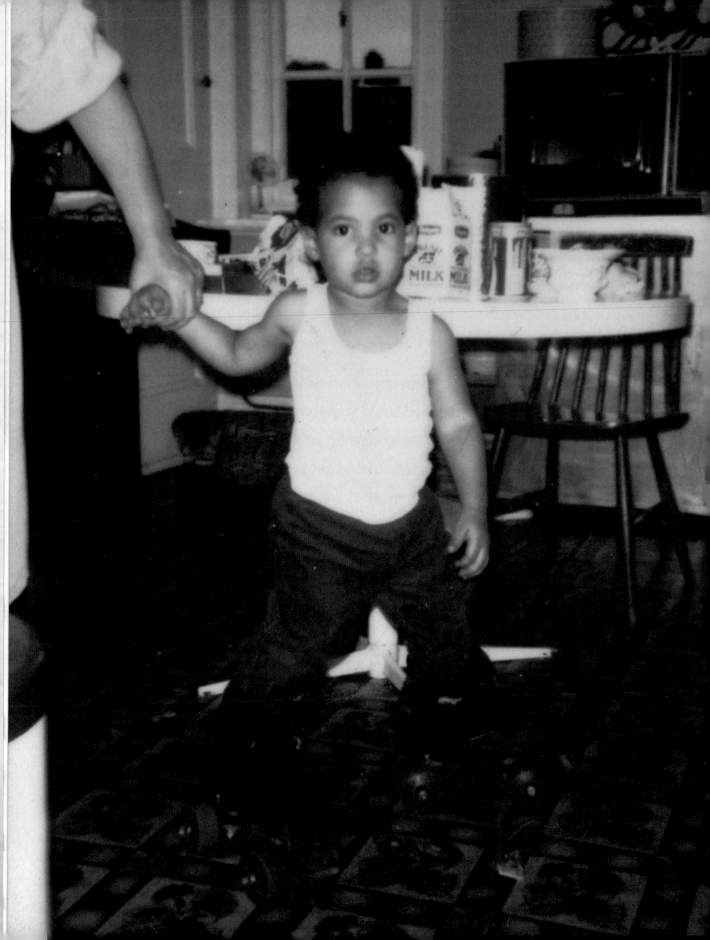

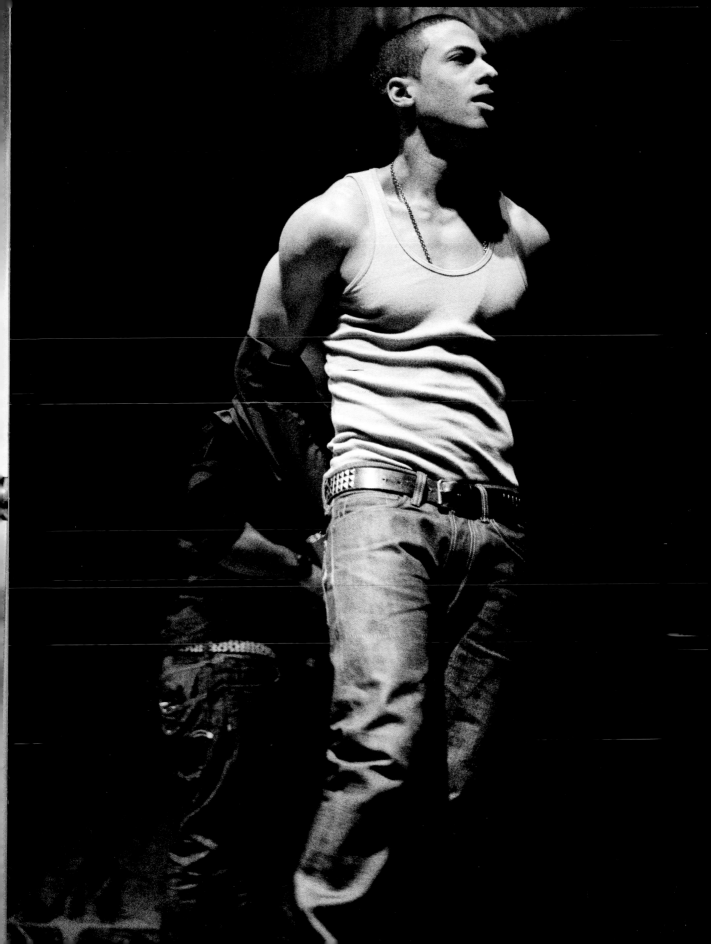

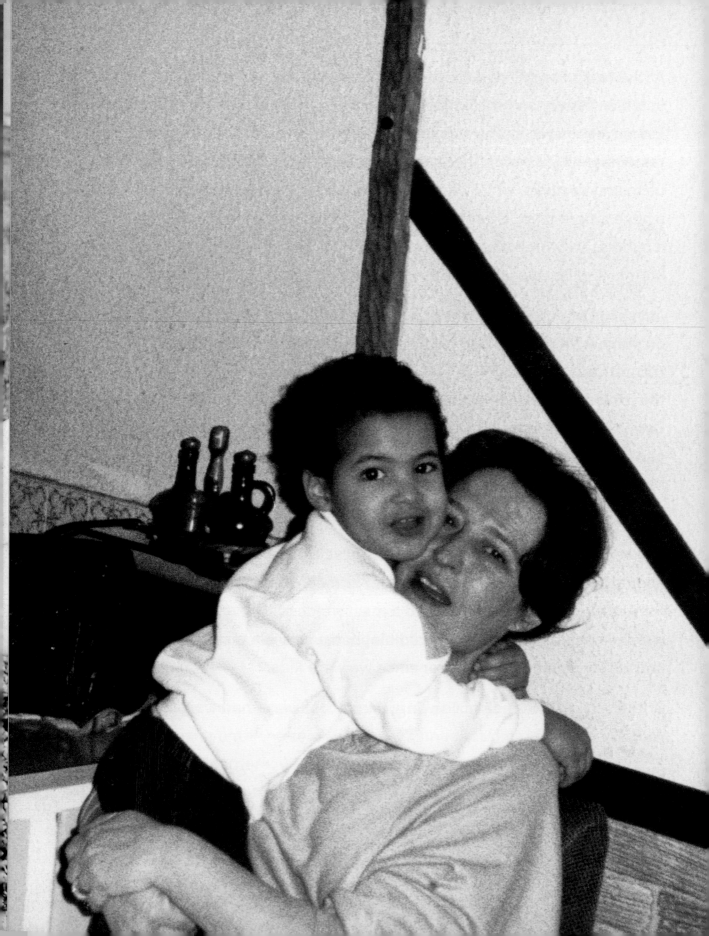

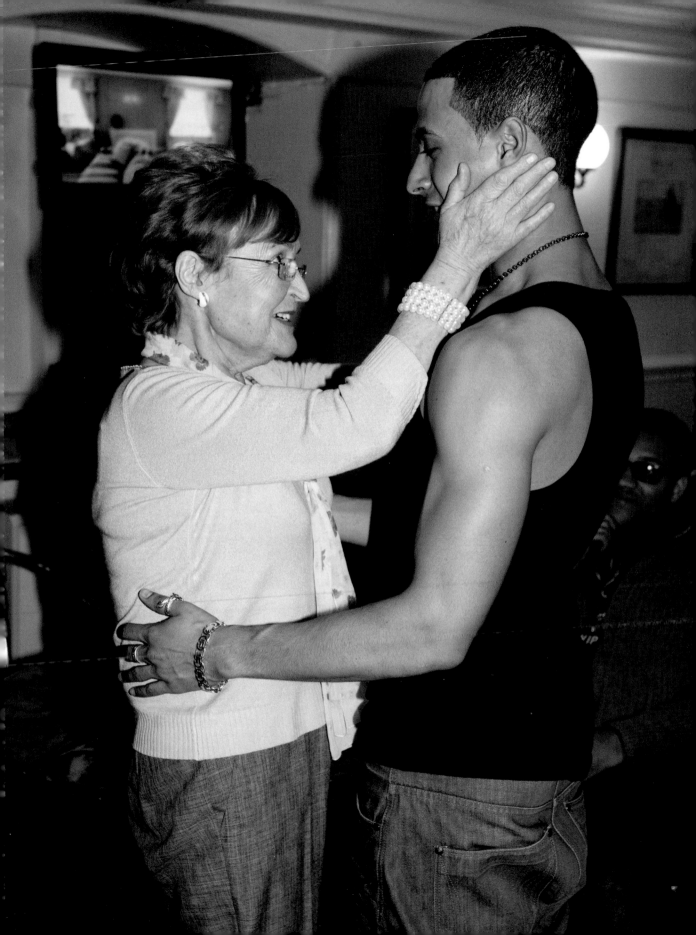

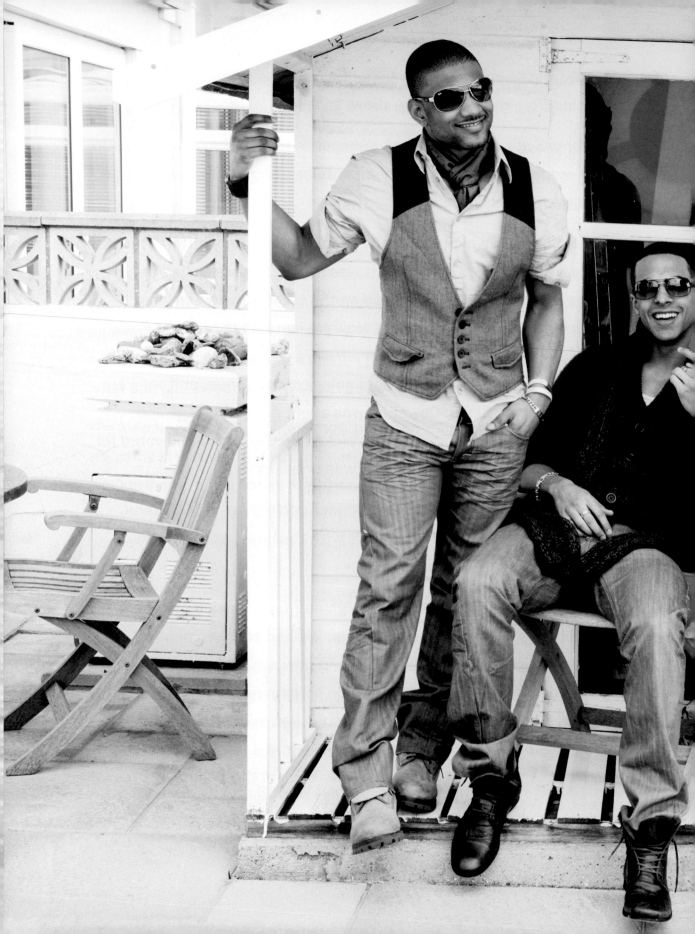

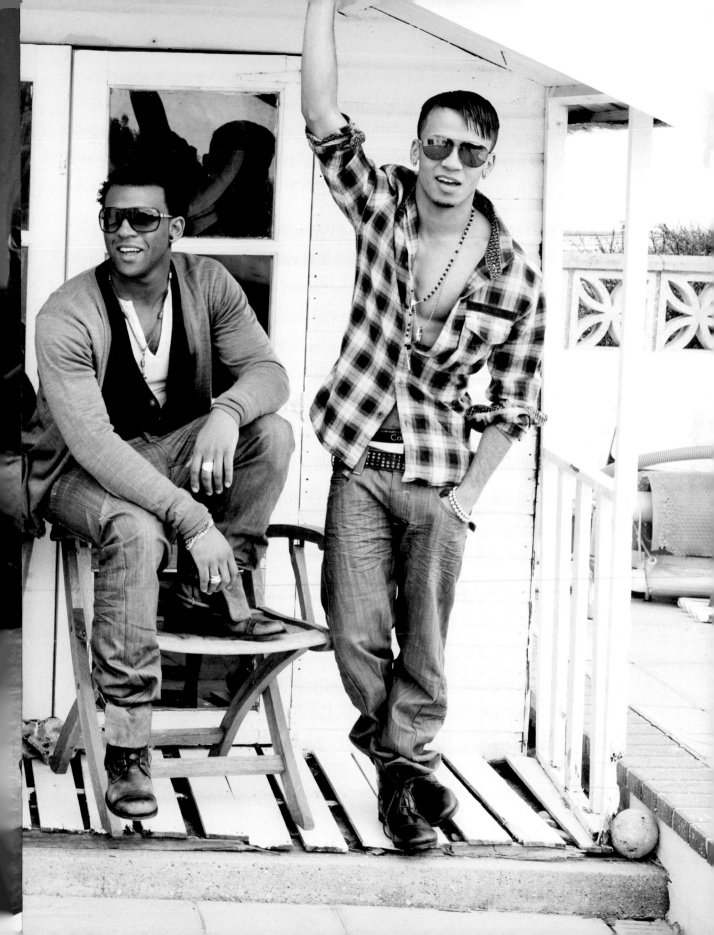

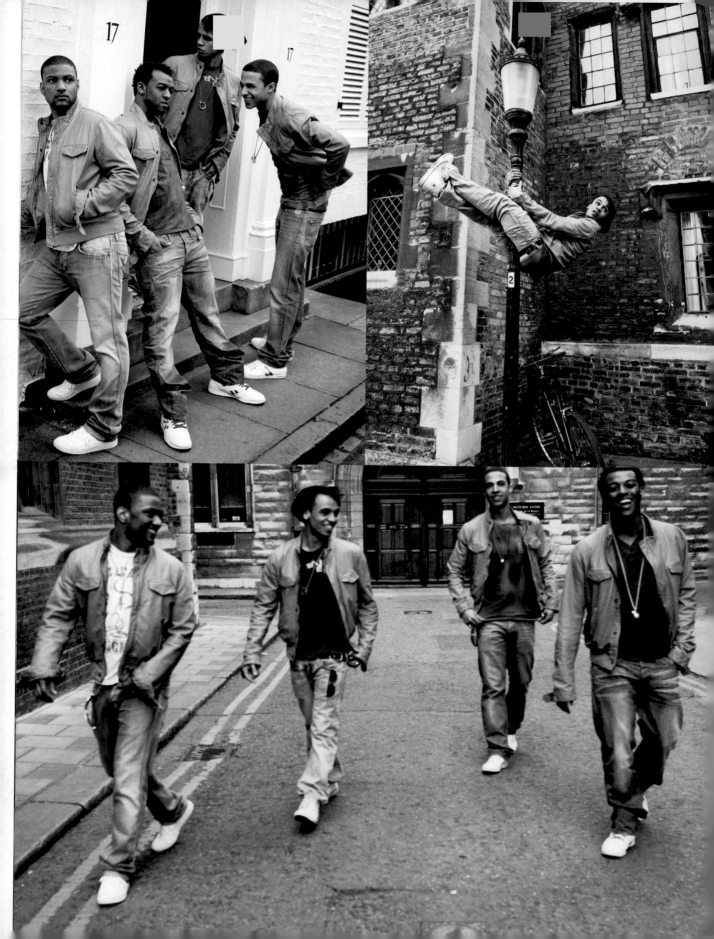

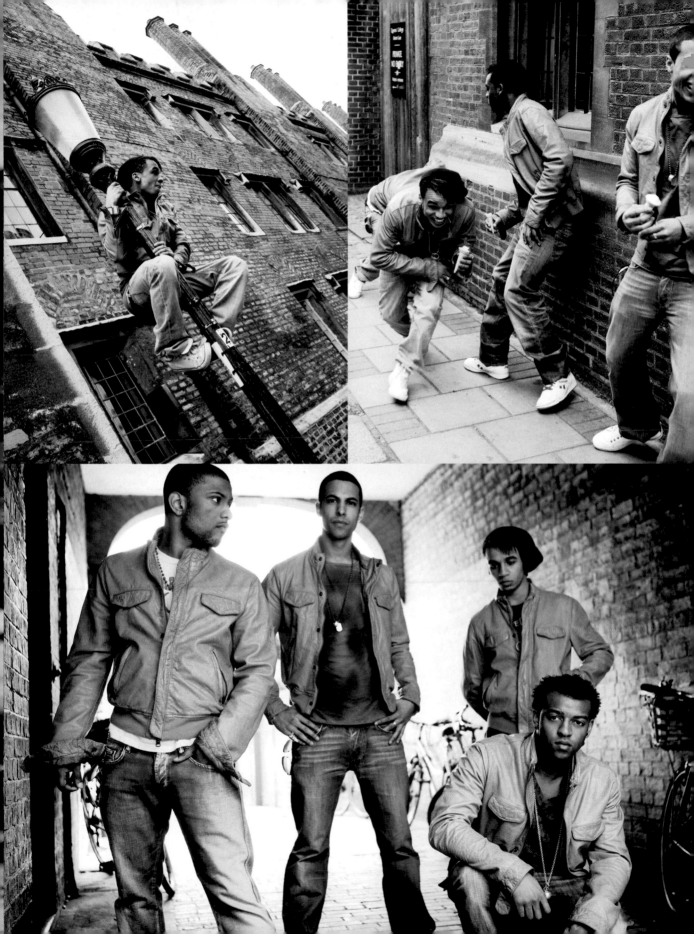

I often fall asleep smiling these days. The best part about this life is realising that I'm doing what I always wanted to do.

I don't care what I have to go through, I thought. I don't care what I have to do for this opportunity. It's got to be done. Somehow I will find a way to pay my rent.

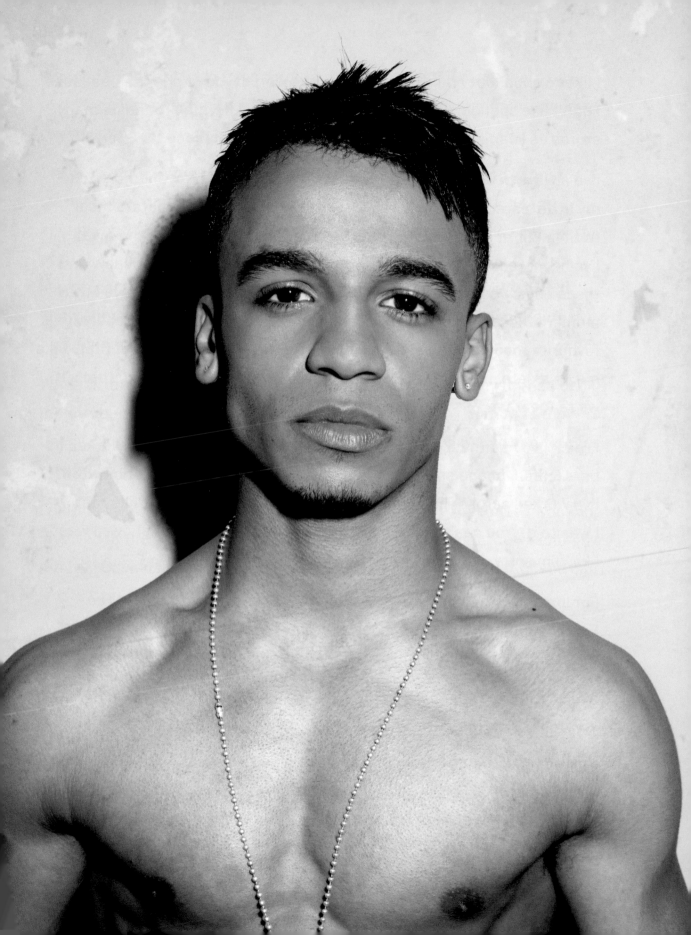

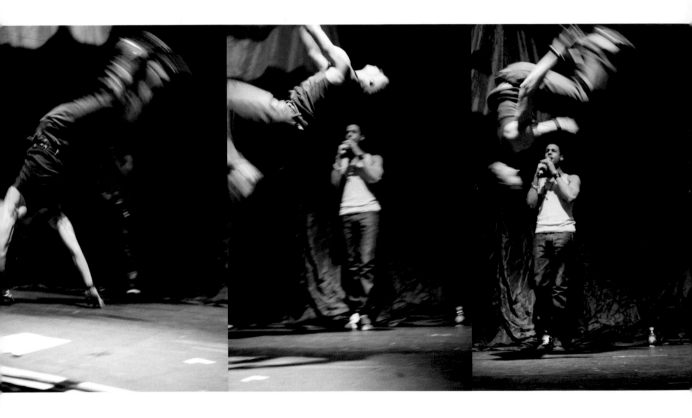

people for the fourth member, but no one seemed to fit in terms of looks and sound.

Oritsé auditioned JB when Marvin and I were both away for the weekend. 'Guys, I think we've found a fourth member,' he said when we met up again. As soon as we saw JB, he seemed right.

We took the group seriously from the beginning, but on the other hand I was still going to auditions: I was getting into the final few for West End shows and TV shows like *Britannia High*. 'Boys, if I get through this audition, it could be really big for me,' I'd warn the others every time I got close.

'We'll work around it,' they said. 'If you have opportunities, you've got to go for them, but we're still going to be here.'

It was the same for us all: we were all juggling. JB and Oritsé had university to worry about, and Marvin had the same issues as me, like working to pay the rent. But none of us wanted to leave the group.

Then JB's auntie said, 'You lot should definitely do *The X Factor* this year!'

At first, we thought, 'Mmm, *X Factor*, it's not very cool . . . ' But it turned out to be the best thing we've ever done, individually and collectively.

At the first *X Factor* audition, we looked around and realised that there were no other boy groups like us in the whole place. Yes, you had your boy groups, but they weren't distinctive like we were, in our brightly coloured polo T-shirts, shorts and Converse.

Someone came along with a camera and pulled us out of the queue. 'Your sense of style is great,' they said. 'Would you come outside for a second to do a quick thing for the cameras?' We were pleased, because we'd

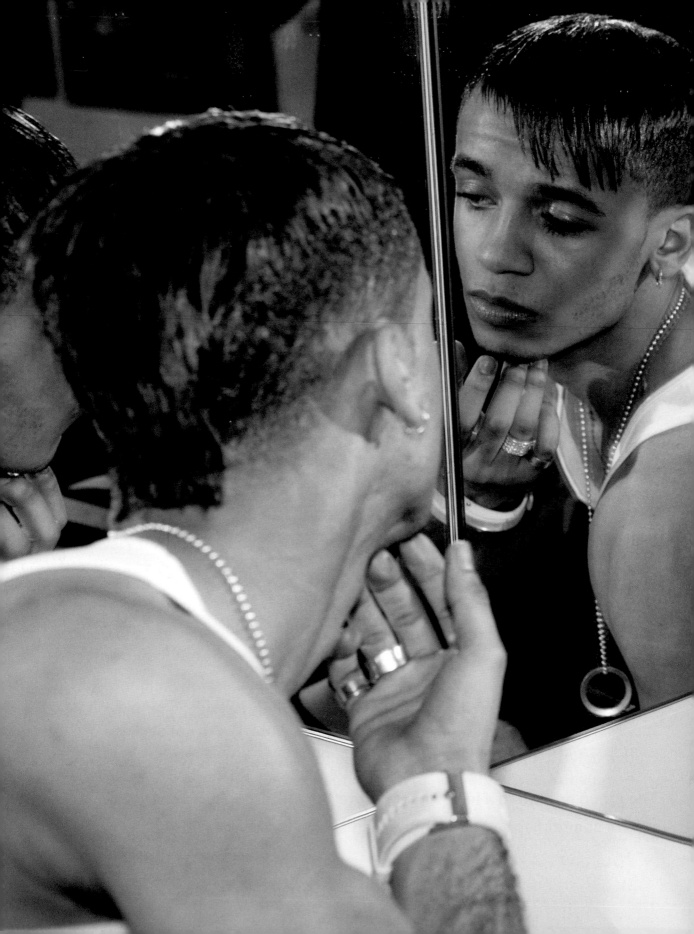

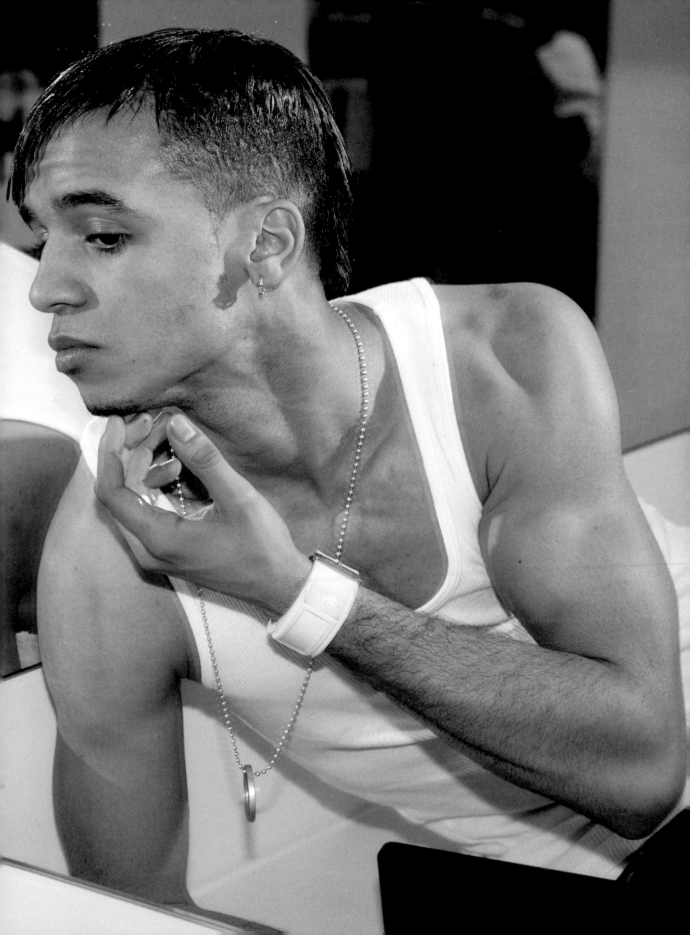

do that the other boys can do. Marvin and Oritsé's range is a lot lower than mine, so either one of them would most likely take the lead on a lower track.

JB is just a wizard when it comes to harmonies. He can pick out harmonies from anywhere, and he can sustain them for a long period. So he's the one who is mostly nominated to harmonise with the lead vocal, and I've been picked to do most of the vocal leads so far.

There was one week on *The X Factor* when I sang the lead and we ended up in the bottom two. It was really hard: it was my fault and I take the blame for it. Anyone can have an off day, though. The week afterwards, I was still doing the lead, but the others backed me up and did a lot more on the song, which really worked. It was one of our best performances of the series, according to Simon Cowell. We sound fantastic when we're all singing together.

That week was definitely the low point of the competition for me. It wasn't the worst performance of the night, but the emotion got to us, especially me, as everyone saw on screen. But that's just the way *The X Factor* works. Only the other day we were saying how weird it is that you can sing one song on a Saturday night for just two minutes and your voice will be tired for the rest of the week. But you can sing five tracks on tour, every single day, twice a day, and your voice remains fine. That's because the *X Factor* experience tires you out mentally, physically, everything.

The stress levels were high but the four of us always kept each other calm and cool, except that one time. When it came to singing the survival song to stay in the competition – 'Stand By Me, Beautiful Girls' – we had hardly any time to listen to the versions we would be singing. Marvin and

Oritsé were listening to one CD player and JB and I were trying to listen to the other one, but the CD player wasn't working. We couldn't hear the track and we began to panic. 'We've got three minutes to listen to this whole song. What are we going to do?' It was mad. In the end, we did manage to listen to it once through before we went on, fortunately – but only once, and once isn't enough.

When it came to go on stage, there was no time for any emotion: it was just a case of 'Let's do this!' But it was hard watching the judges' faces as we were singing, because they looked surprised that we were in that position, and kind of upset.

After the performance, there was so much pent-up emotion inside me that I just broke down. I had to get the cameras out of my face, so I ran to the toilet, where it all came flooding out. I just couldn't remember anything about the performance – and still can't to this day. Oritsé was there to comfort me, but then all the cameras came into the toilet and I totally lost it. The whole thing really shot me down; it was crazy. I felt so strongly that I wanted to go back, sing the song again and do myself justice. But of course that wasn't possible.

We did well if you look at the circumstances, but we can sing that song a lot better. Still, we managed to bring a vibe to the stage and we were lucky enough to stay in the competition.

The judges were great. Louis Walsh is definitely one of the funniest guys I've ever met. He just doesn't mess around: he doesn't take any shit and he's very honest and forthright. If he doesn't like something, he'll tell you. Obviously it's the best way to be, but he really is so direct, it's unreal, and it makes me laugh.

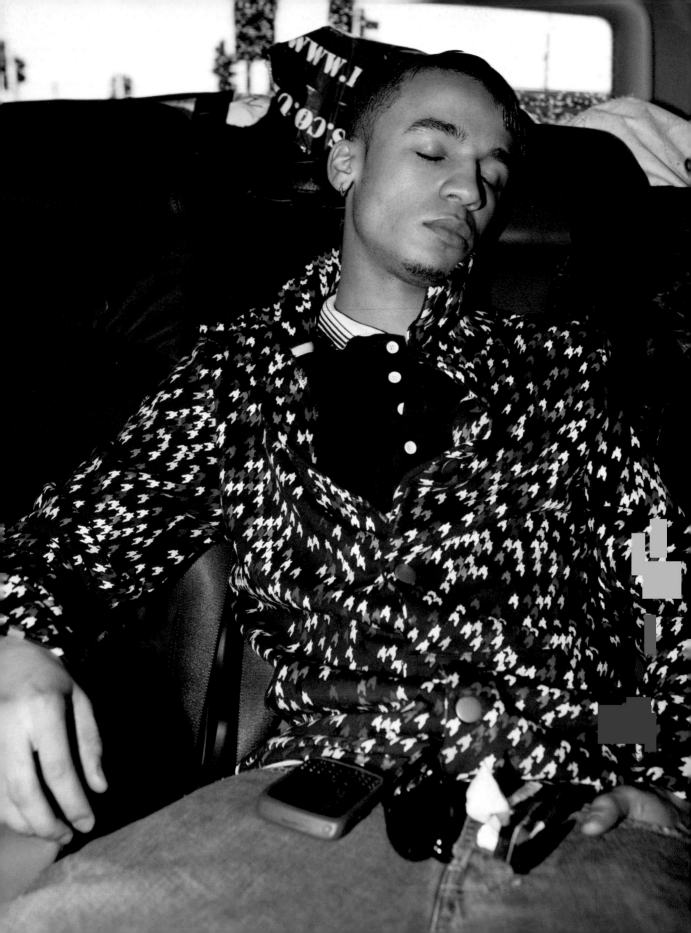

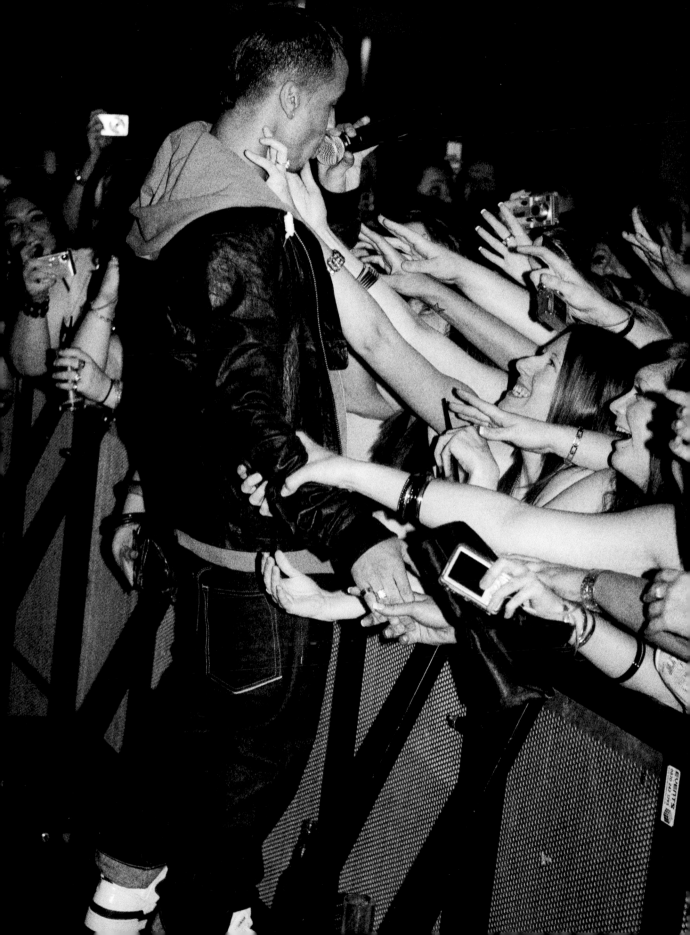

He said that we were the first act since Shayne Ward that's he's felt emotionally involved with. There was one week when he actually cried because he was so worried we were going to get knocked out of the competition. We couldn't have asked for a better mentor. He was very professional. He always told us if he thought something wasn't working. What's more, he often asked for our opinion and listened to it – and he'd be willing to go with it if we felt strongly enough about it.

A lot of stuff went on behind closed doors that people don't get to know about! For the Best of British week, we were going to sing 'Rule The World' by Take That, because we already had a version of it rehearsed before the show started. We always wanted to showcase the song somewhere in the show, but there was never a right time to do it. So with Take That week coming up, the producers said, 'Don't do it in Best of British; please do it in Take That week instead.' So we were more than happy to sing the Beatles track that week, because we were guaranteed 'Rule The World' the week after.

But then Dannii took the song for her act! We went into her dressing room to argue our case. 'We don't know what's going on here, because we had our heart set on this song, and everyone knows that,' we said. Everyone knew that JLS were going to sing 'Rule The World' and no one else wanted to sing it, because we were all very close.

In the end, Rachel sang it, which we thought was a bit unfair, but we accepted it, because it's a competition at the end of the day. Unfortunately Rachel went out that week.

As for Cheryl Cole, if I fancied her any more than I do, I'd probably need a restraining order! Basically, we all got along with Cheryl. She was very

friendly and always came to say hello to everyone. One time, during rehearsals, I was sitting at the very top part of the studio, at the back. When Cheryl came into the room, everyone said hi. She looked up at me and shouted, 'So are you too famous to come and say hello to me now?'

'Come up and say hello to me,' I said cheekily. So she did.

The boys were like, 'Wow!'

'Yeah,' I said smugly. 'Me and Cheryl have this bond and we're close like that!'

Simon Cowell kept himself to himself, but opened up a lot more towards the end. After the quarter-finals, we went into his dressing room, and he said, 'That was amazing, guys.'

Weeks before that he'd given us some good feedback, but he didn't really talk much until the end, when there was a possible record deal up for grabs and potentially the need to build a relationship. He seems like a great guy and funny, too. All this stuff about Simon Cowell being scary is a bit overdone: at the end of the day, he's giving his opinion and it counts for a lot. He's just really cool.

Hearing our name called out in the semi final was really amazing. Wow, to be among the 185,000-plus people who auditioned and make it to the final three acts was incredible! It was crazy really to think that out of all those contestants, the judges and the people at home wanted us in the final. It was great to get to that stage and know that we'd be getting gold, silver or bronze, which had been our ultimate aim all along. We had wanted it to happen so much, but we didn't expect it, so it felt as good as scoring an overhead kick in the World Cup final!

OVERLEAF: ASTON AGE THREE IN HIS GRANDPARENTS' BACK GARDEN (MUM IN THE BACKGROUND) SQUIRTING THE FAMILY WITH THE HOSE

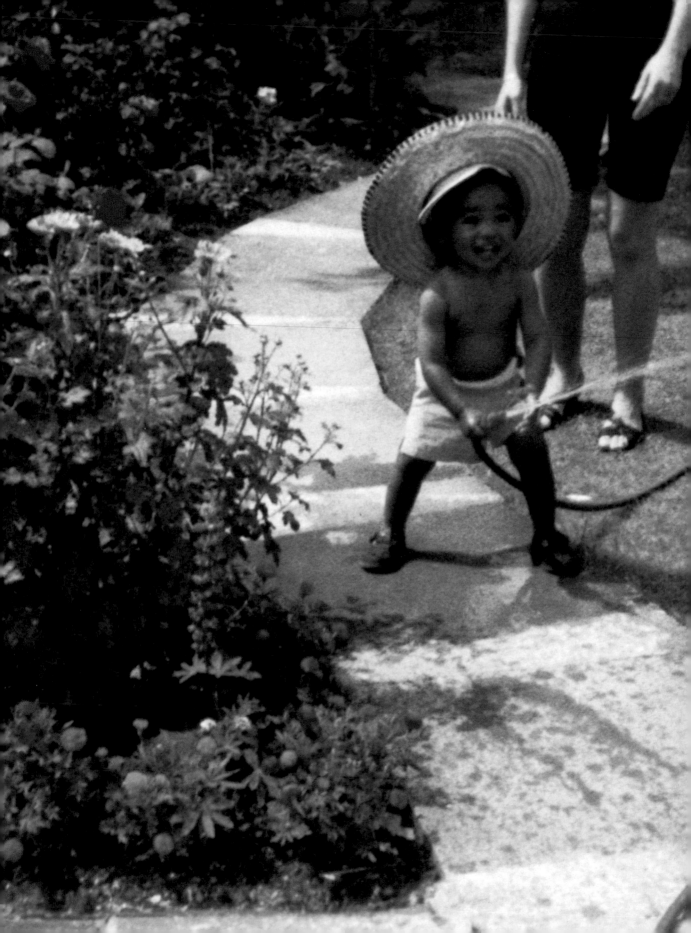

My uncle said to me 'Wow, that's really good! You remembered the words, you can actually sing really well!' I didn't clock it at all. No, that didn't mean anything to me, I was just singing a song. I was really young.

Next came the tour and I love performing live – we all do. After appearing at the O2 arena, I walked through my door and thought, Wow! An hour ago I was on the O2 stage and now I'm in my bed! When I used to see people in concerts, I never thought about what they did afterwards, but obviously, they go to sleep just like everyone else.

I often fall asleep smiling these days. The best part about this life is realising that I'm doing what I always wanted to do. Even now, it doesn't always compute, though. When you're doing something you've wanted to do for a long time, it's a dream come true, however clichéd it may sound, because you are actually living your dream.

We're becoming better known all the time, which is great. At first, people knew us as the blue one and the yellow one, but now it's getting to the stage where they know our names. On Google, if you type in 'blue JLS' it will come up with me, 'yellow JLS' and it will come up with JB, so everyone's getting more familiar with us.

We work very hard, but we're really happy with that. So if we wake up at four in the morning, six in the morning, ten o'clock, or even if we wake up in the afternoon, we always wake up with smiles on our faces, thinking, 'We could be in an office right now, doing something we don't want to do.' For someone to want to record our music, take photos of us – even produce a book with us – is just amazing.

It was brilliant being on tour with Lemar. We had such a fantastic time. But one night in Cardiff there was a blackout while we were on in the middle of our set. Everyone was trying to usher us off stage, but we were adamant we were going to stay on and do it. You only get a certain amount of time on stage as a support act, so we weren't going to give it up!

Instead we sang a song a capella to the crowd, with two roadies holding torches to light us. The audience loved it! Not blowing our own trumpet, but I'd love to see someone else in our position handle that as well as we did, because I think a lot of people would have crumbled.

We've performed in clubs where we've had to sing four-part harmonies on one mic, which a lot of people think is impossible. But I think all four of us feel that nothing is impossible now. We've overcome big hurdles in the past: now they're getting higher, but we're jumping higher.

OVERLEAF: ASTON AGE 9/10 DOING A MICHAEL JACKSON DANCE FOR THE WHOLE FAMILY AT A CHRISTMAS PARTY (GRANDPARENTS' HOUSE)

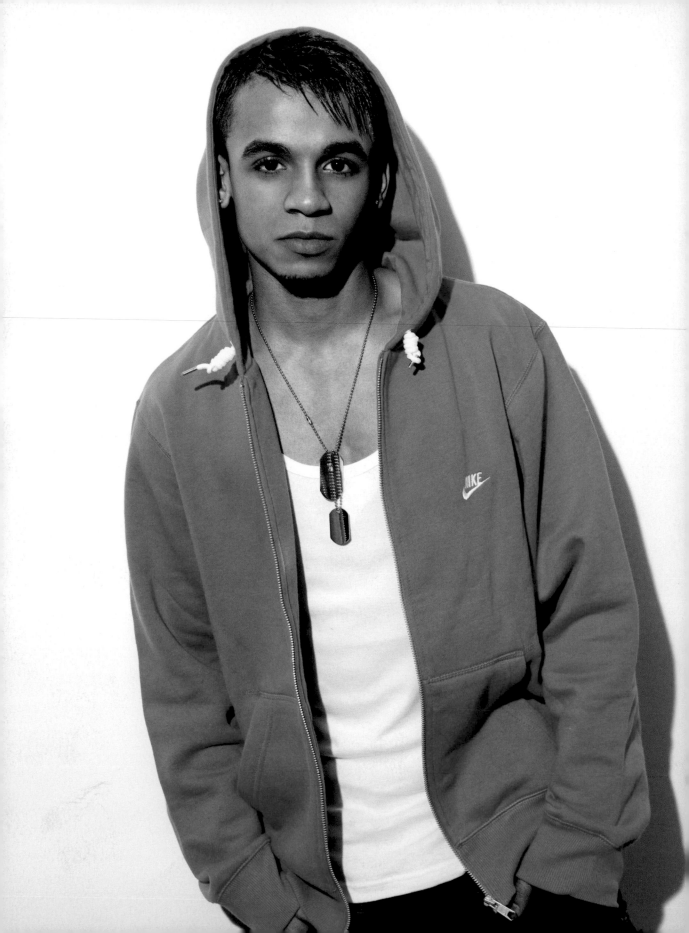

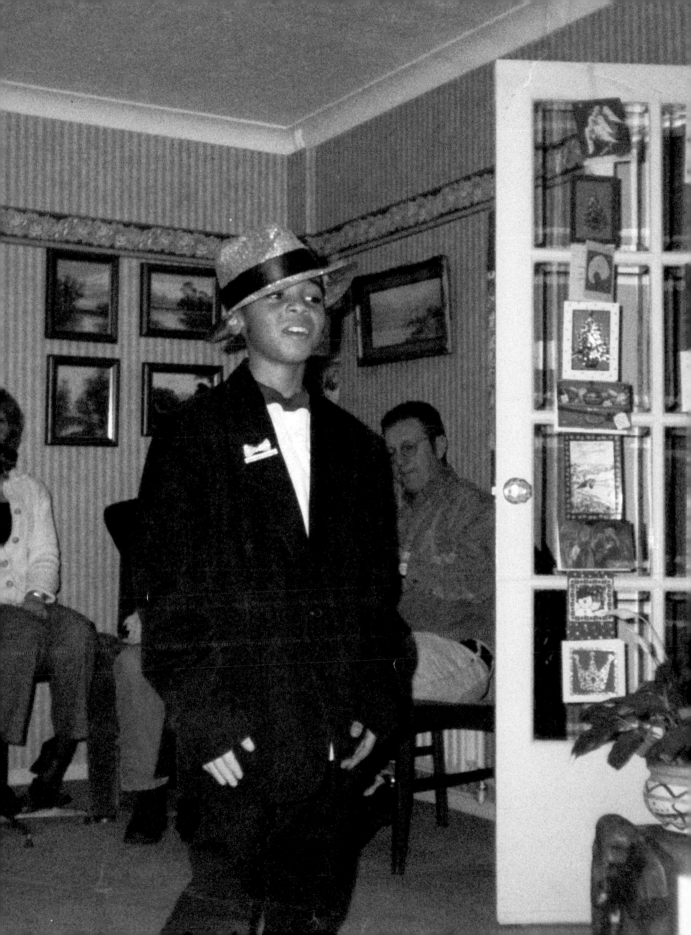

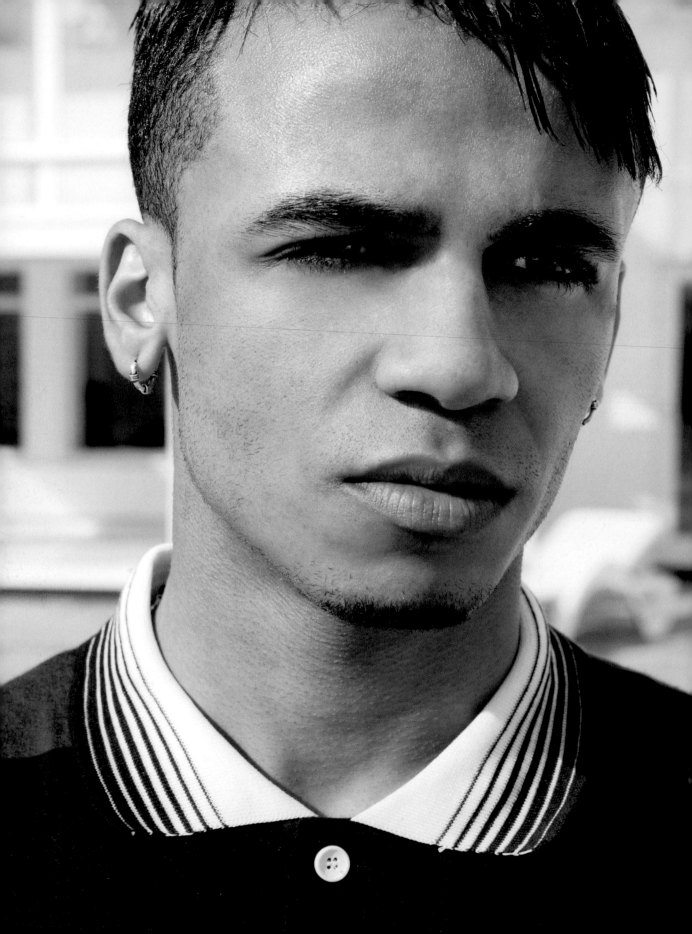

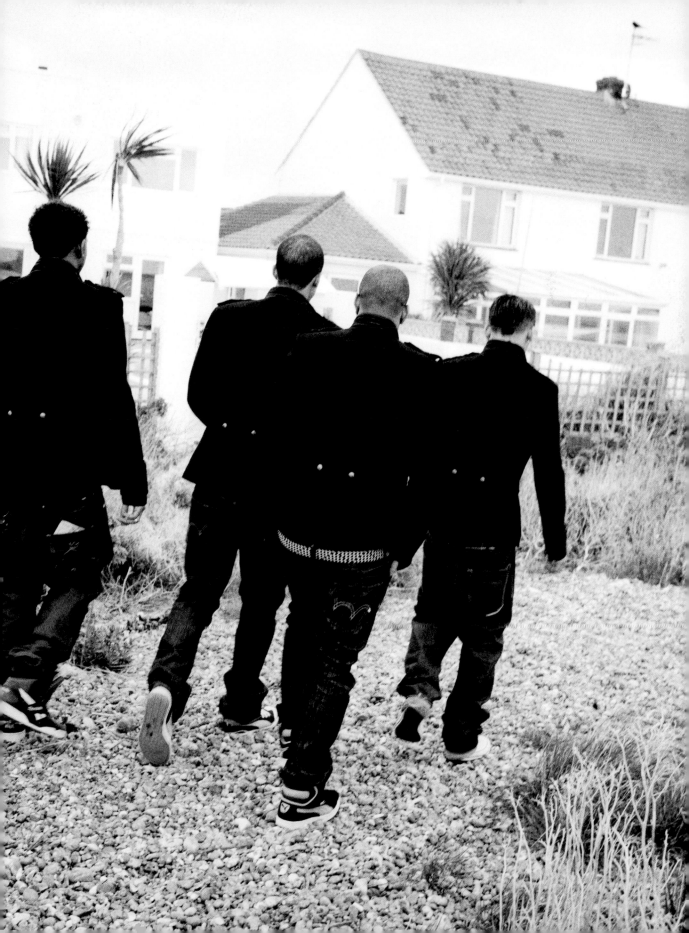

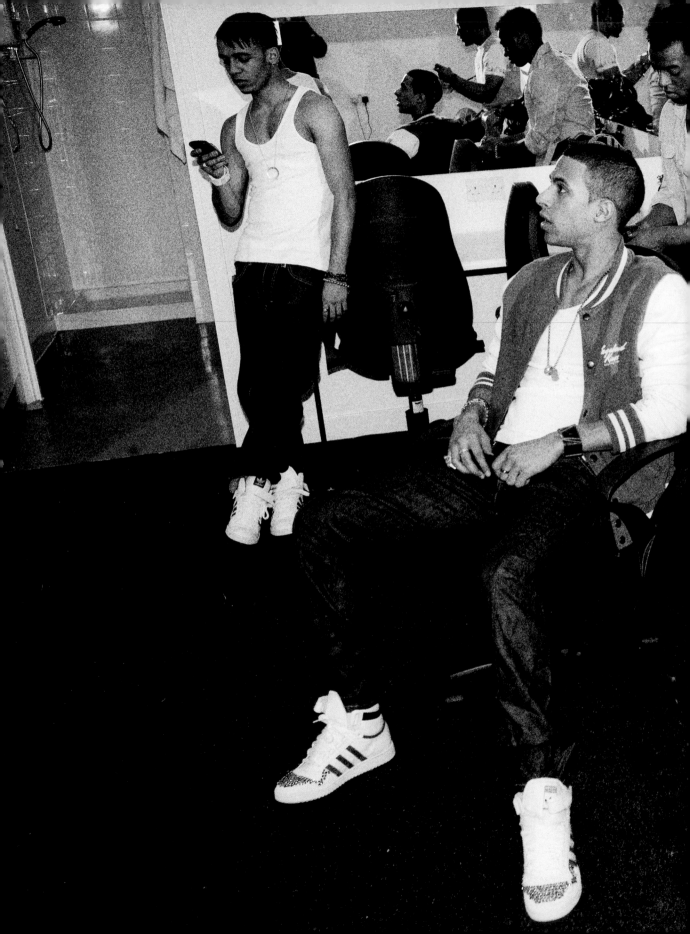

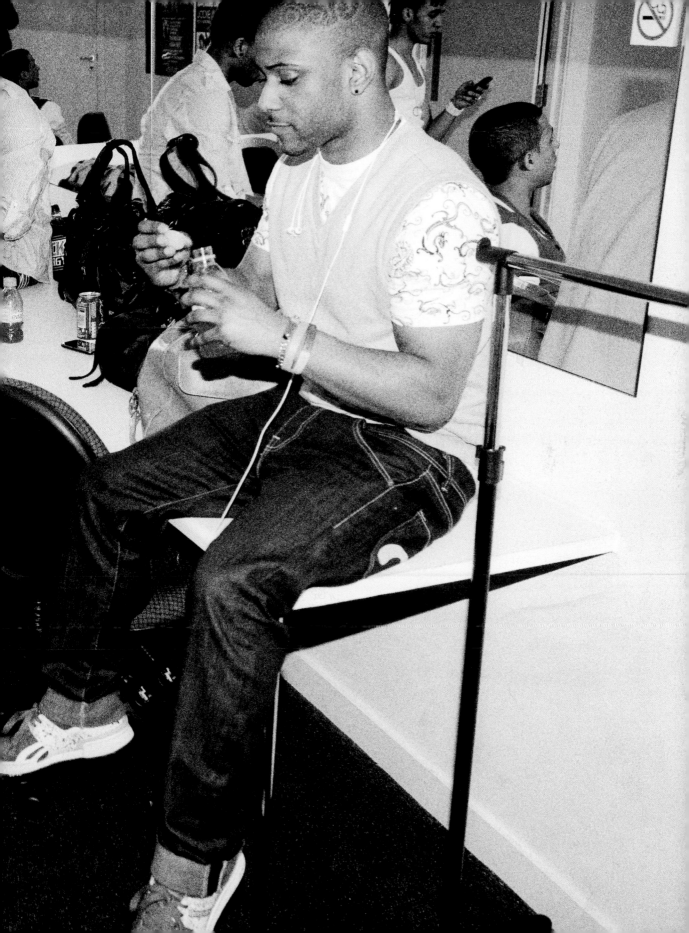

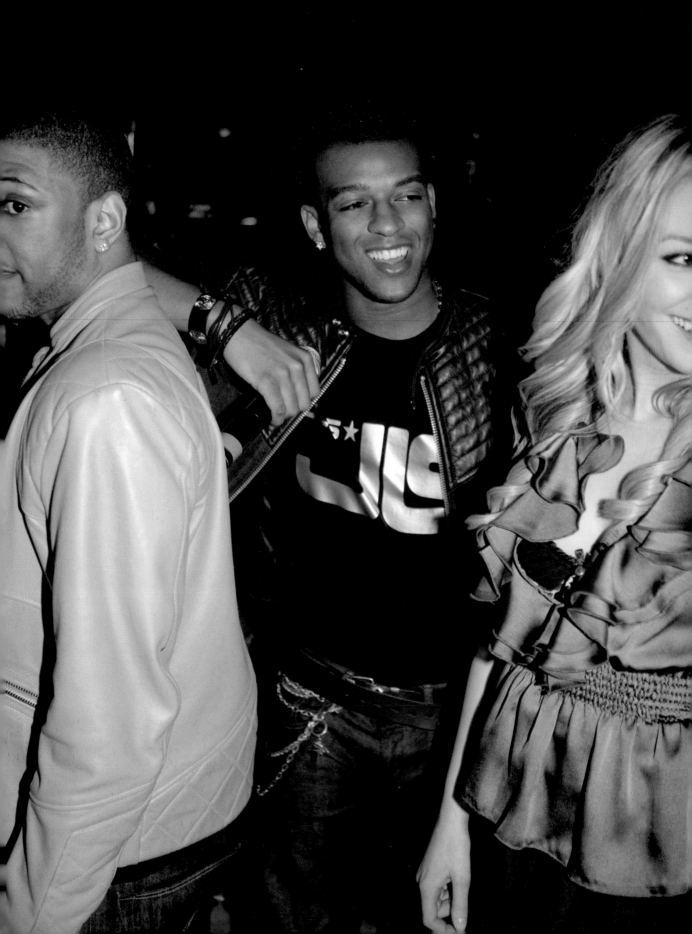

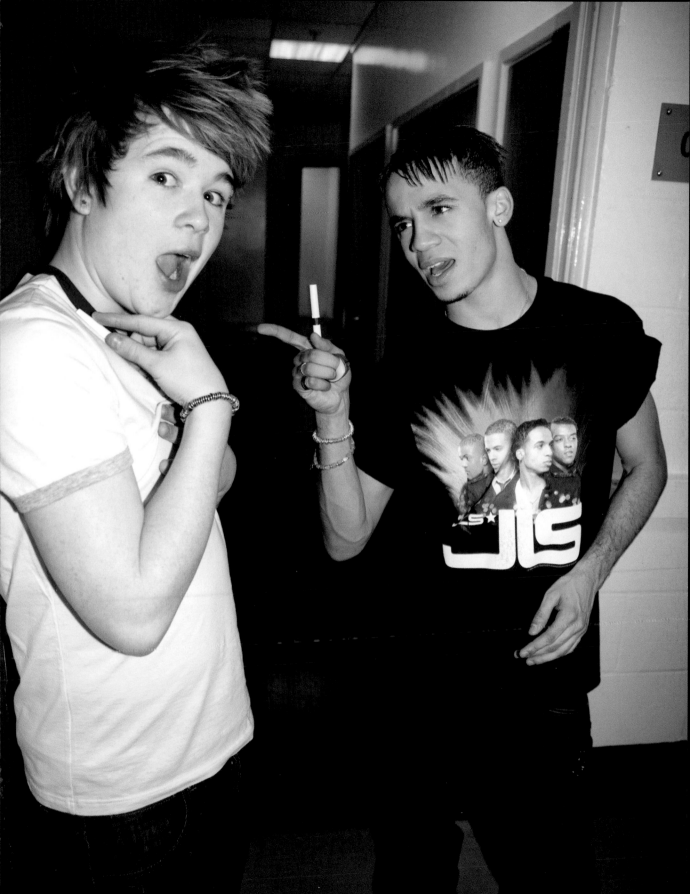

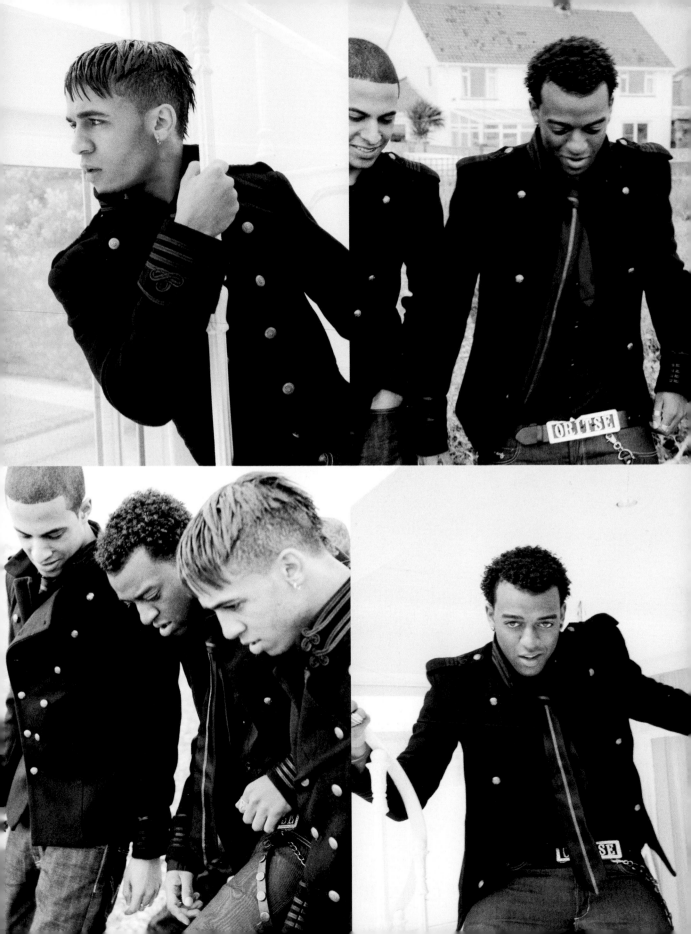

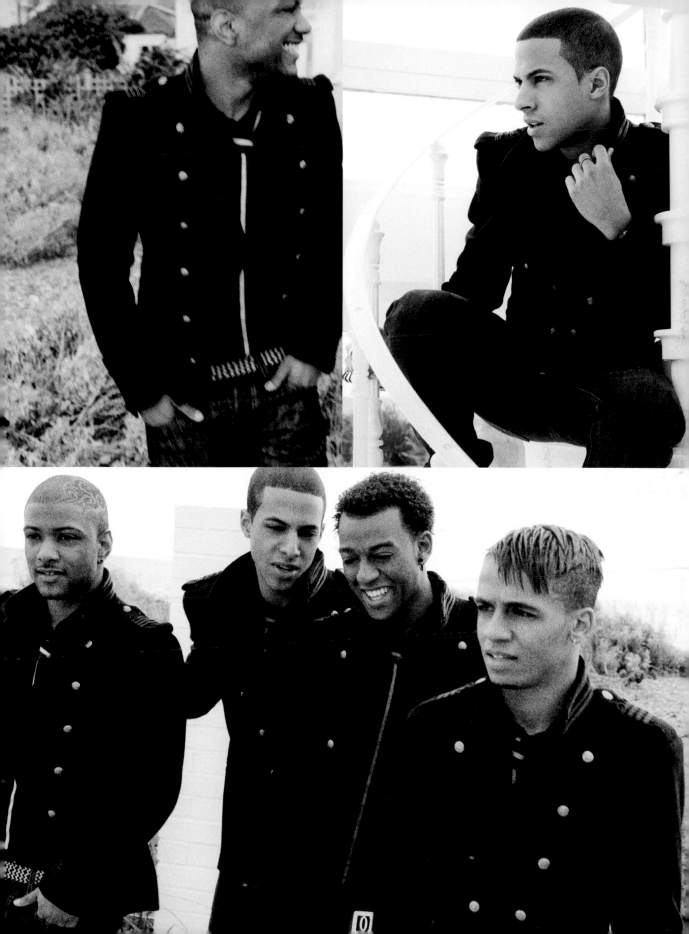

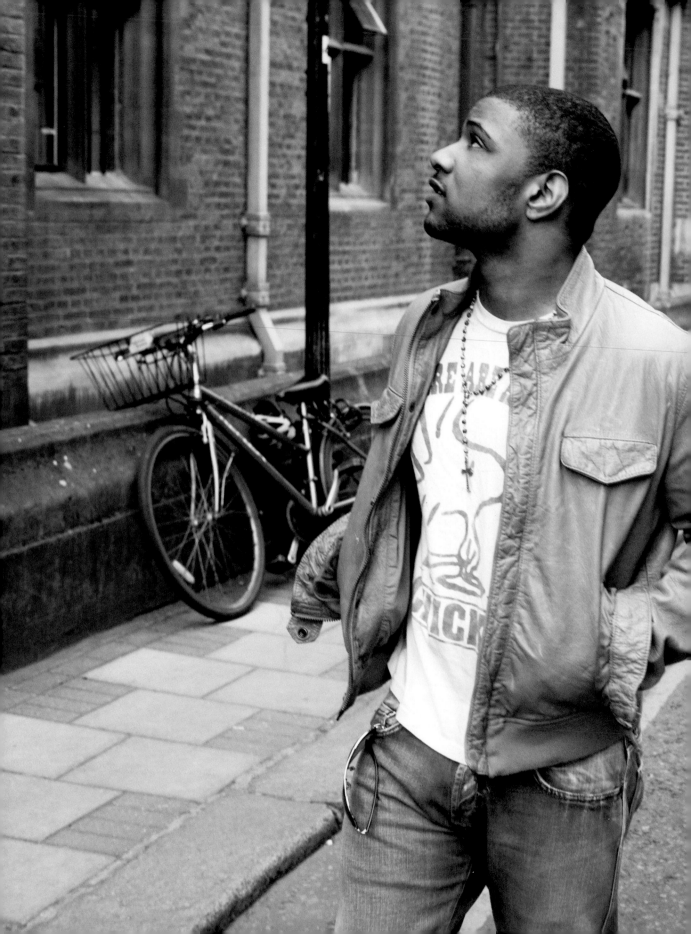

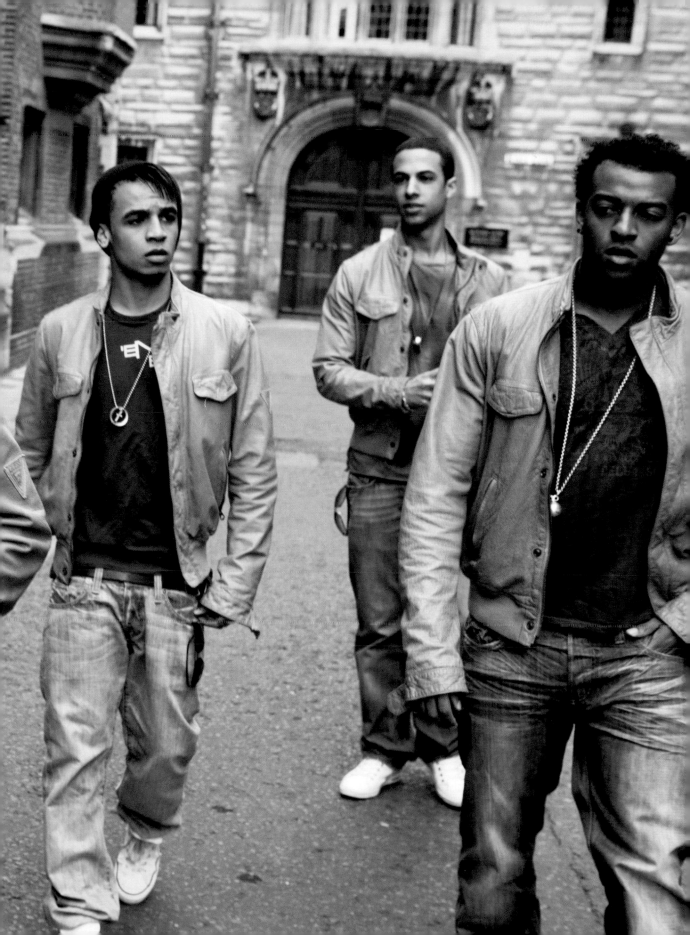

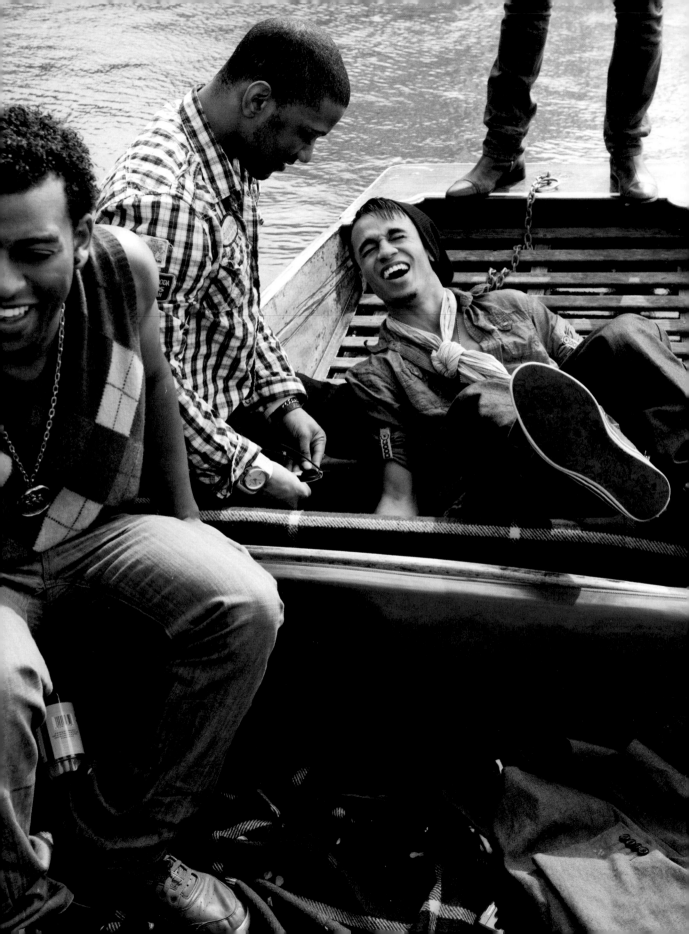

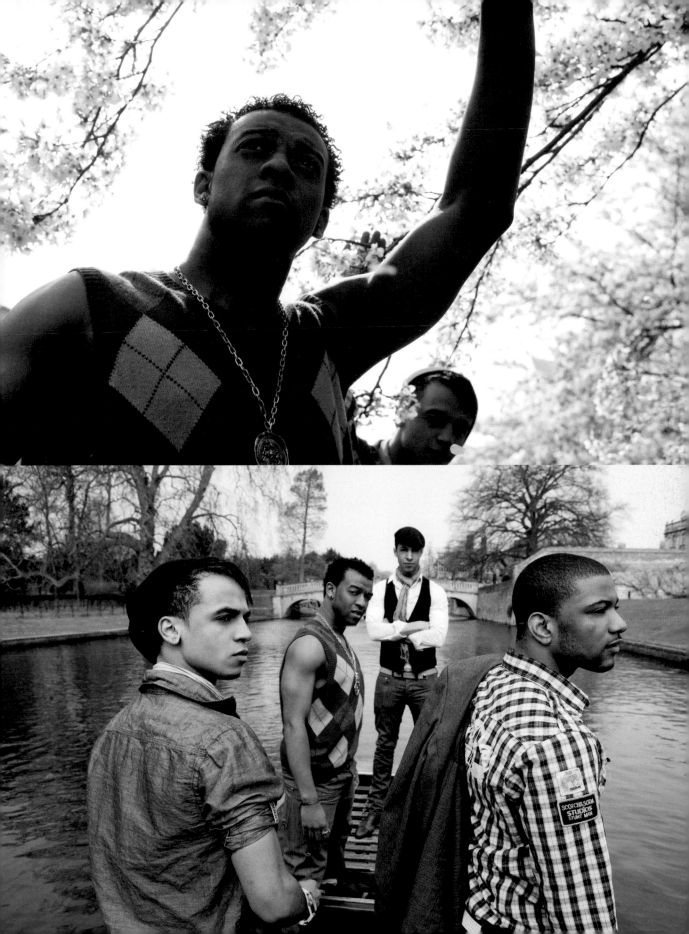

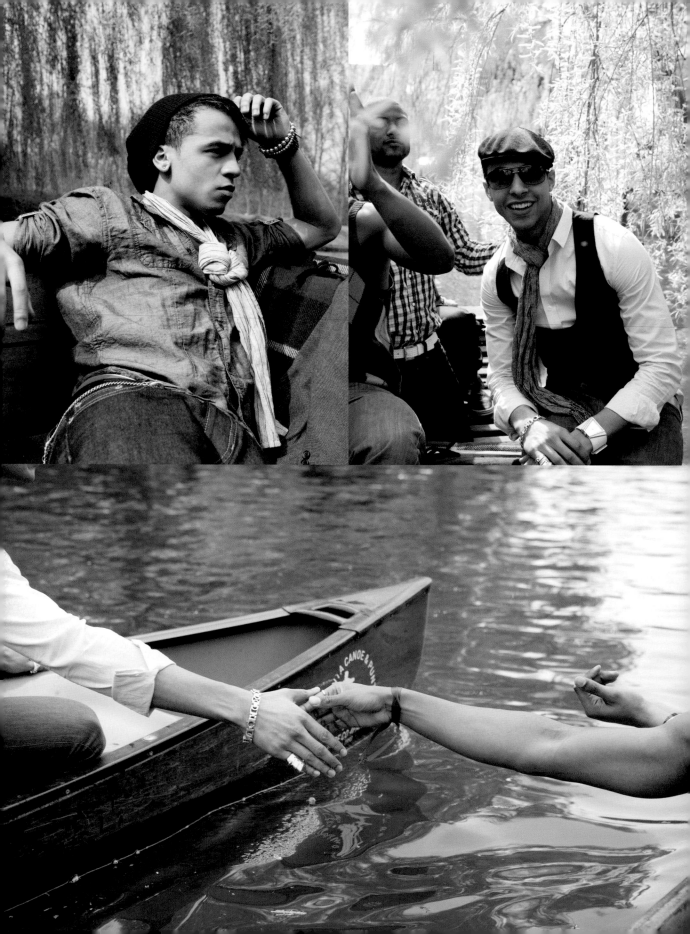

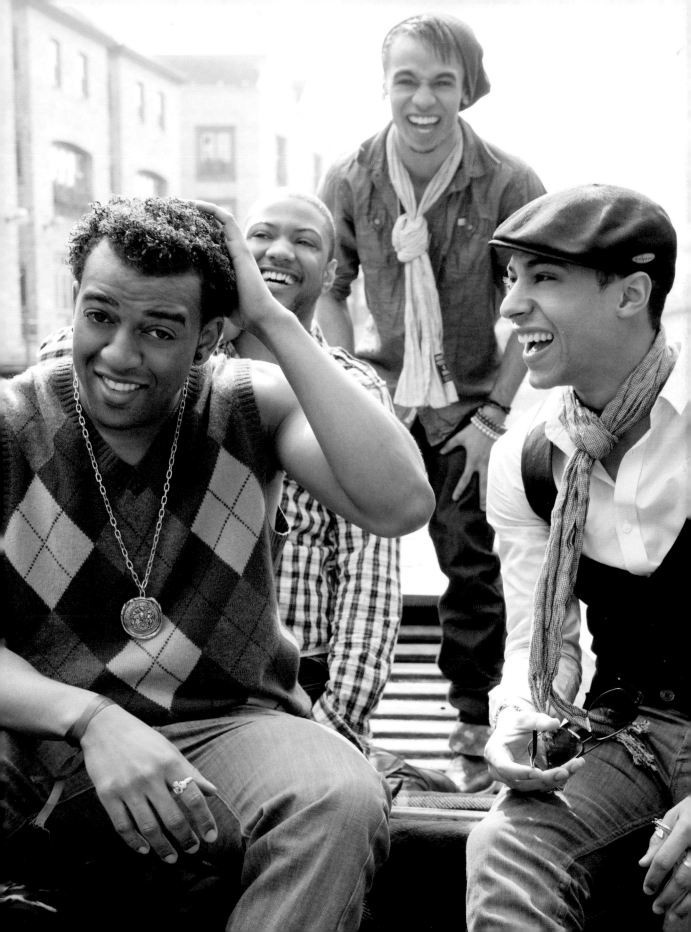

I loved playing music by ear, whether it was a jingle from the television or a song from the radio.

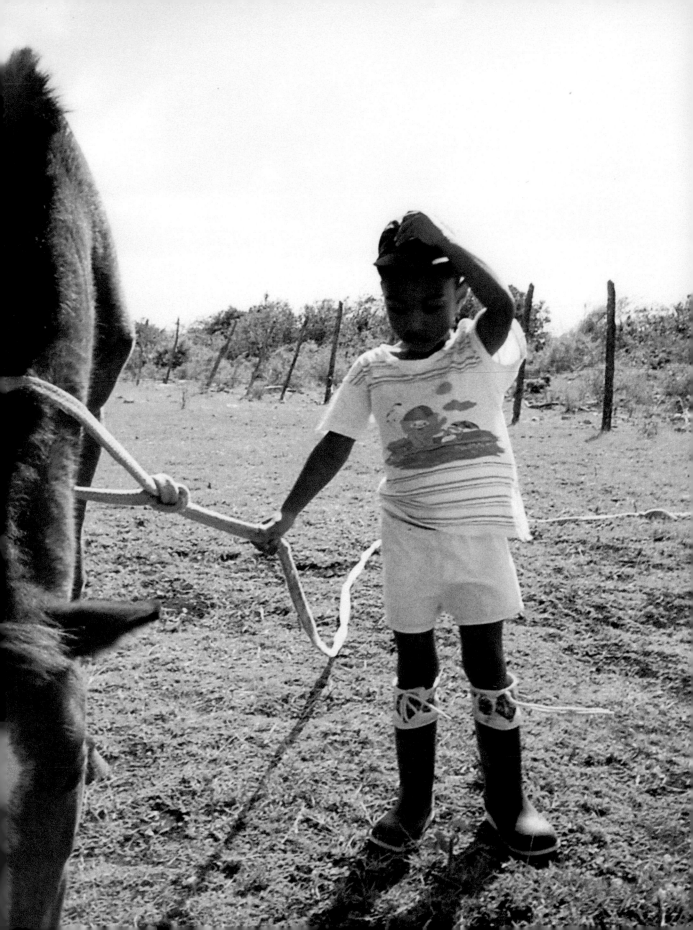

JONATHAN 'JB' GILL

AGE: 22 / DATE OF BIRTH: 7 DECEMBER 1986 / STAR SIGN: SAGITTARIUS

As a group, we're the perfect combination, I think. Oritsé is very much a hustler. If you need something done, he'll find a way to do it. If you want to be on a particular television programme, he'll find a way to speak to whoever he needs to speak to in order to get it done.

Marvin, on the other hand, is very good at communicating with people. You could call him a charmer. In fact, I'd definitely call him a charmer! He's very good at liaising with people, which is vital in this industry. He's a bit of a diplomat, actually – DJ Trevor Nelson even called him a politician!

151

Aston is the definition of an entertainer. If you need him to run, jump, or do something that no one else wants to do, he'll do it, hands down. If you need one person to be the life and soul of the party, it's got to be Aston.

As for me, I'm kind of an in-betweener, to be honest. I can do a bit of everything. I'm not an out-and-out entertainer, I'm not an out-and-out diplomat, I'm not an out-and-out hustler, but I'm always thinking. I am definitely a free thinker. I can be quite hard on the business front too, which is obviously good when you need to negotiate and put things in place. I like to take my time to think about things like contracts.

OPPOSITE: FEEDING THE HORSES IN ANTIGUA AGED FOUR!

The boys will tell you that I'm very much the perfectionist in the group. They tend to tease me for it, especially Marvin and Oritsé, but I won't apologise for it as I think it's absolutely necessary. Things have to be done properly. Going into the studio is about repetition, about perfection; it's about trying to get the right vocal sound and making sure that the track is the best it can possibly be, because it's going to go out to thousands if not millions of people. If we want to go on to be as big as Westlife or Take That, if not bigger, we'll have to be as disciplined as they are. We're professionals now.

I've had a connection to music since I was one, according to my parents. For my first birthday I was given some drums, which I instantly loved. That was also the day that I walked for the first time, so it was quite a big occasion.

Some of my favourite baby pictures are of me with a big Afro, biting my orange drumstick. I didn't go on to play the drums though. Instead, I became really good at the recorder when I was about six or seven and I went on to play the flute to Grade Six.

I'm London born and bred. I grew up in Brixton, but went to secondary school in Croydon and moved there when I was about thirteen. I was in the choir all the way through school – my school choir was amazing – and we even performed at the Royal Albert Hall. I also played the piano and the guitar. I loved playing music by ear, whether it was a jingle from the television or a song from the radio. I was never as good at the technical side, though; learning my scales nearly killed me.

I gave up playing instruments when I was about twelve, because as I moved up to the higher grades, there was much more emphasis on the

technical aspects, when all I really wanted to do was play the pieces and feel the music. At that time I didn't even think about being in a band. I loved classical music but thought a career in music was all about orchestras. I couldn't really see anything productive coming from playing my instruments.

From thirteen, I went through a phase of playing rugby. I took it very seriously and played at London Irish Youth Academy and for Surrey County RFC; I was playing five or six days a week and wanted to make a career out of it. When I realised that I wasn't going to play professionally, I went back to music, which is my core. My mum really pushed that side of my creativity as well.

My parents are quite strong people, especially my dad. I was born on the same day as him, so I'm probably like him in more ways than I know. My school was great for my confidence, too. The bottom line there is excellence. We used to strive for excellence academically, in sport, in music – in everything really, across the board. I absolutely thrived there. The school certainly stood me in good stead for what I'm doing now.

Music and sport were always hugely important – and then, as I grew older, I became interested in girls. I've had a few girlfriends and I would say that I definitely felt love for one particular girlfriend. I met her when I was about sixteen and I was with her for two years; it was my longest relationship. I wasn't really that interested in her at first, which is a bit unusual, but she kind of grew on me: I ended up spending more time with her and then it just popped off. She was down to earth and I like that, so we got on very well. She also approached the relationship in the right way for me, because she wasn't at all jealous.

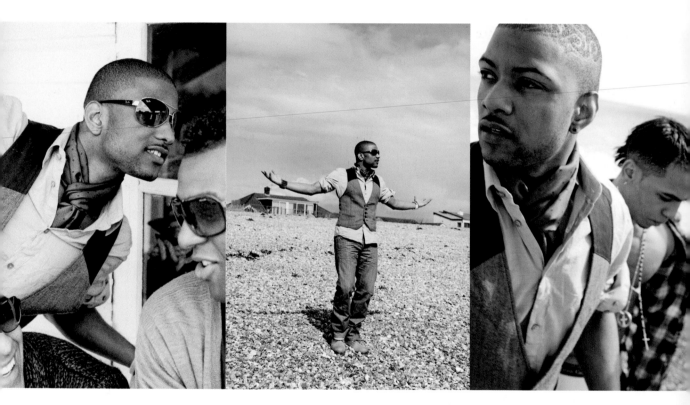

If I'm honest, I'm a romantic at heart. I look at things this way: if you're going to be with somebody, you have to take care and you have to take time. You have to think outside the box, because people like that, or at least some people do. Most people like a surprise; they also like to be looked after and pampered.

I like to treat people, but a present doesn't necessarily have to be expensive: it's about the quality, about being thoughtful. It can be really nice to send somebody chocolates because you know they had a bad week last week, or send them something to their place of work because you know they came top in their area or were the best salesperson at their job. It doesn't just have to be on Valentine's Day. I must say that I find that holiday a bit of a cliché, although I do still like to do something for it.

I'm attracted to girls who are intelligent and who have common sense. She doesn't have to be university material, but she has to be able to think for herself and take the initiative. I don't have a particular physical type, but there's something about gorgeous eyes that makes me forget about everything else!

A lot of our fans are female, which is great. It's really flattering that so many girls like what we do. But sometimes when I see how our fans react to Aston, I just have to laugh. I can't do anything but laugh, because it's just funny the way they can't contain their excitement when they know they're actually going to get to stand next to him. I have to admire how he deals with it, as well. I know I'd struggle to handle that level of attention. Still, we all get attention from girls now and it feels quite natural these days – not to say that I expected it or I've had it all my life, but I respect the fact that they're expressing themselves.

I quite like to chill on a date. It's good going out to dinner, but I'd probably prefer to pop into Nando's and then go to the cinema, or go ice-skating. Something simple like that. I've been ice-skating on a first date before – at an outdoor rink – and it was a lot of fun. It's good to have something to do while you're getting to know someone. When it comes to eating out, my favourite food is probably lobster. I absolutely love it. Still, I'm not fussy. I could easily eat Nando's every single day, if that was what was available.

I think men and women are very different. Of course, I also think that they should have equal opportunities, but women are better at some things and men are better at others. You have to look at each individual case and see what each person is good at. For example, women are safer drivers, in my opinion, but men are better at parking. So what's my driving like? It's very relaxed, for a young guy. I'm certainly not a boy racer. I have a VW Golf now, but my ideal car would probably be an Audi A4.

All my life, I've had a lot of drive and determination. When I joined JLS, I was at university, in my first year at King's College, London, studying Theology. I was also writing songs and working with a vocal coach called Karla Celeste, who worked for an artists' development company. Even then, I was always busy with something. I didn't know the meaning of spare time.

I was the last member to join the group. Karla met Oritsé and Oritsé asked her if she knew any guys who might be interested in joining a boy band. 'I met this guy and he sounded really cool,' she told me later. 'Are you interested in joining a group?'

Well, I wasn't really looking to be in a group at the time, because I was trying to work more towards my songwriting. But I enjoy being part of a

team, which is why I love rugby, and I like working with people because you can vibe off them. OK, I thought. I'll give it a try.

As I've said, if I'm going to do something, it has to be done properly. So I wasn't prepared to be in a group just for the sake of being in a group. If I was going to join a group, it had to be a group with members that had their heads screwed on, people that I could actually relate to and be involved with on a personal level. I'm quite family-orientated, so I like my friends to be involved with my family and vice versa; I like to be involved with their family and friends as well.

I met Oritsé and we had a drink. He asked me to come and audition, in a loose kind of way. Obviously, he wanted to see if I could sing, first and foremost. I told him that I write as well, so I went down and sang him a couple of tracks that I'd written – nothing special, but he really liked them. He said that he thought I could be a good addition to the group, so I went back the following week and did it all again in front of Aston and Marvin. After I'd done my thing, I went outside and got on the phone to my mum, because she wanted to know what time I was coming home.

'The boys are talking it through and they're probably going to be about ten minutes, so I'll ring you back then,' I told her. But mid-phone call, they'd already decided that I was in the group.

I was pleased, of course, but I had to be certain that they were the right guys to be hanging around with. I said to them straight, 'First, I have to make sure that this is going to be a viable option for me, because I'm not going to do things by half.' It was May and I was doing my first year uni exams at the time. 'I can come down to rehearsals, but I'm not going to be rehearsing full-on until I finish my exams,' I explained. They were happy with that.

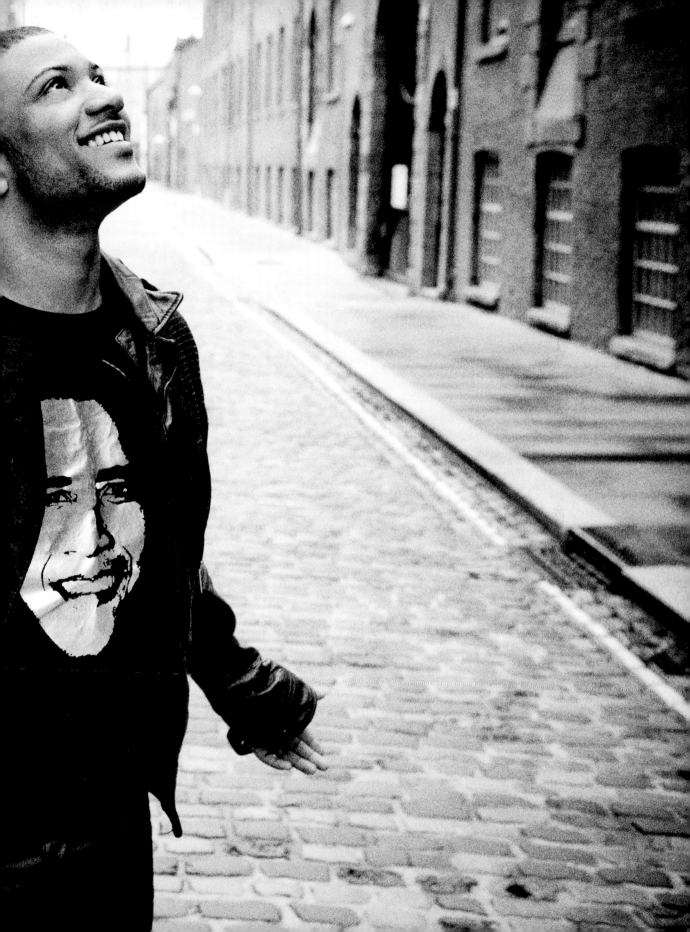

Once I'd finished my exams, we started rehearsing properly. I loved the fact that they had a great work ethic, because I think that when it comes to something you love, there's nothing better than going after it and making it happen. They definitely had that mentality as well. 'Cool,' I thought. 'I could fit in here.' It was good.

We slotted into place from the first rehearsal and soon found our individual roles. We were headstrong, but we could compromise. To be honest, it was beautiful and unique. There was a magic to the way everything came together.

It wasn't easy for me to work full-time on two different career paths, especially as we weren't being funded. We had to find our own money for clothes and to look good and all the rest of the things that come with that. We were going all out and at the same time I was trying to do my studies, which was hard. I kept trying to get extensions for my essays, but I was effectively told that I couldn't get special treatment, because I was supposed to be a full-time student.

My university sat up when they saw the first live *X Factor* shows and after that I was able to suspend some of my course works. I handed in most of them, but there were a couple that I missed literally because I just didn't have the time to do them. It was just too difficult to manage, really. I had lots of late nights, studying or rehearsing.

To earn money, I worked for my parents on Saturdays and any days that I had off. I helped out as a landlord's agent for my dad, who works in property, and did a lot of admin for my mum's consultancy. I was living at home at the time, because renting would have been an unnecessary expense.

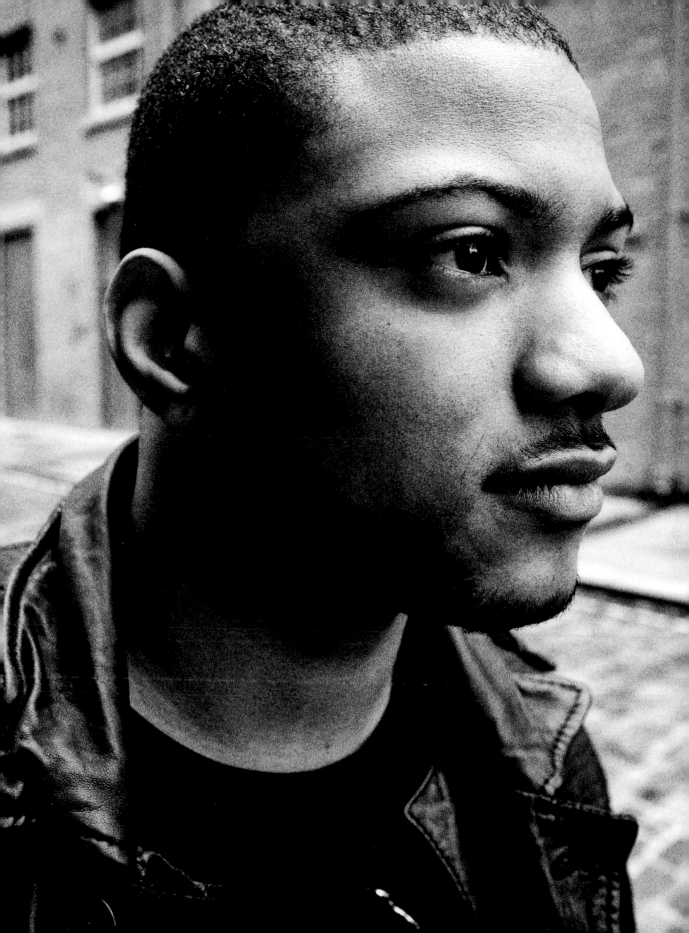

Where I come from, education is always key. But at the same time, when you have an opportunity like this and it's a career path that you want to take anyway, you should definitely try and go for it. It wasn't like I fell into it. I had always wanted to be in music and had made a promise to myself that I'd be earning a full-time income from it within six months of leaving university.

Obviously the industry is quite fickle and success is not always guaranteed. One day you're in favour and the next you're not, so it was important to get my degree first. It was my insurance. And you can go into all kinds of professions with a Theology degree, from law to journalism to management. But first I had to give this a try, wholeheartedly.

I couldn't be at university full-time and do the group full-time so I left uni after my second year, when we'd been together for just over twelve months. *The X Factor* started in April and I finished uni in June; judges' houses came in August and then the live shows began in late September.

Before the first audition, we stayed with Scott, a friend of Marvin's, in Welwyn Garden City. He was kind enough to put us up for the night. It made things easier, because we could all get ready together and travel down together on the train. We barely had any sleep the night before and we had to get up really early, but we were all bouncing with energy.

We stood outside the O2 in the rain for about an hour, in shorts! But it didn't dampen our spirits. It wasn't too cold. Fortunately, there weren't many groups and they put the groups through first. So we got there at about half past six in the morning and we were gone by half past nine.

OPPOSITE: EVEN AT PRIMARY SCHOOL I WAS DOING MY CHOIR THING! DON'T I LOOK CUTE!!

It's funny that people wait up till three o'clock in the morning just to see Aston for five minutes. I have to admire it as well. I couldn't do it. When people scream at me, I can't stop smiling.

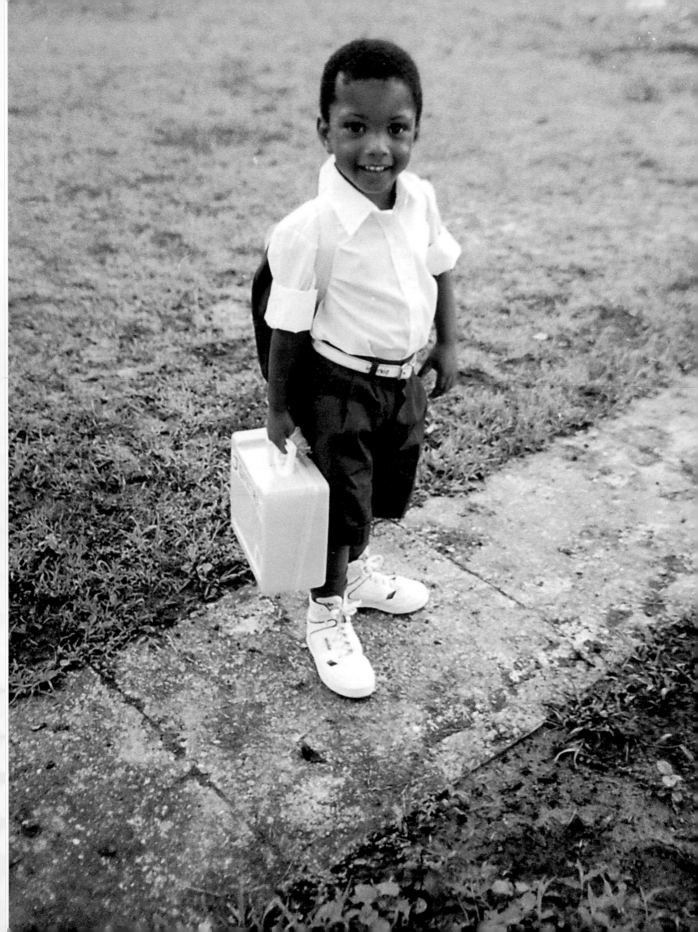

All my life,
I've had a lot
of drive and
determination.

dumb it down. Later on, when we sang 'Hey Jude' at an under-eighteens gig and one of the girls was singing it back to me, the point was proved again.

As for the *X Factor* judges, well, Louis Walsh, our mentor, was really fantastic. He always said to us, 'If you don't want to do a song, you don't have to.'

Louis is just hilarious; he's a great guy, he makes us laugh and he really supported us on the show. We were backstage one day and Austin was talking about us being like the Jackson Five.

'I should be your fifth member,' he said.

'Yeah, you'd be La Toya!' Louis said, and quickly walked off, hand raised in the air: Louis Walsh 1, Austin Drage nil.

To be honest, I think that the girl groups were at a bit of a disadvantage with Louis, because we all know how much he likes working with boy bands. He really gets involved with them, even on the show, so he put a lot into us from an early stage. And obviously we had an even better chance of survival when his other acts went out, because we were his last remaining act.

The other judges were just as nice as Louis: they weren't as involved in our creative direction, but they were cool. Cheryl was lovely. Simon didn't really speak to the contestants much, but when he did, he was really nice. He popped in and gave us little tips every now and then, which helped a lot. For instance, he advised us to change 'Back for Good' to 'A Million Love Songs' during Take That week. 'Keep doing what you're doing,' he said. 'You're really good and we want to see you in the final.'

In some ways we improved as the weeks went on, but on the other hand we were always in a hurry — seven days to learn four-part harmonies is never going to be enough. At the same time, it meant that we became more efficient as a group, because we had to get things done as quickly as possible — especially in the last week when we had four songs to sing. Living together and being together all the time definitely made us tighter. But in terms of the musical side of things, we didn't become as tight as we probably are now, because we didn't have as much time.

I don't get scared going on stage in front of a big crowd. I'm much more nervous if I'm performing in front of a few people or members of my family. So, at the O2 arena, I loved going out in front of 15,000 people. It was just incredible, every time.

I can't stop smiling when people scream at us. It's a fantastic feeling. They love what you're giving them, so I'm more than happy to give it. I had my teeth out all the time when we performed to a packed Wembley and at the NEC and MEN arenas. Some groups don't ever get to go out in front of such huge audiences, so we felt very lucky. Fingers crossed we can progress enough to make it on an individual bill.

Lemar has been fantastic to us and he was kind enough to allow us to join his tour. We get a really nice vibe from him. There's a lot to learn from him, too, because he's on his fourth album now, and he comes from a similar background: he did *Fame Academy* and he's been successful in forging his own career off the back of that.

It's amazing that we went on to sign to a label after *The X Factor*. Now we're making money doing gigs and club PAs and we're going to have an album out. There are loads more things in the pipeline, too, so watch this

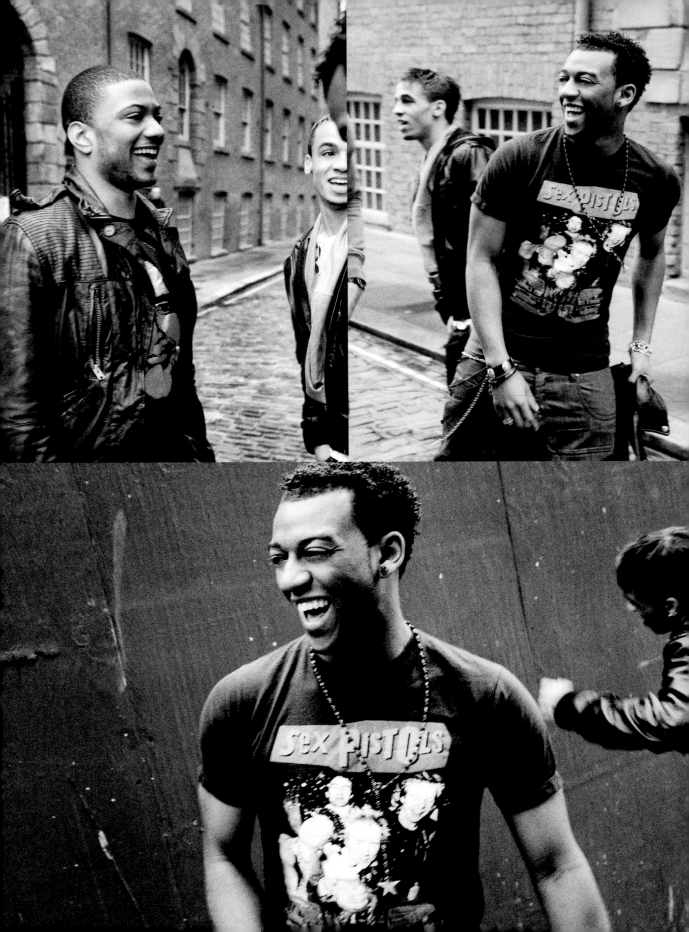

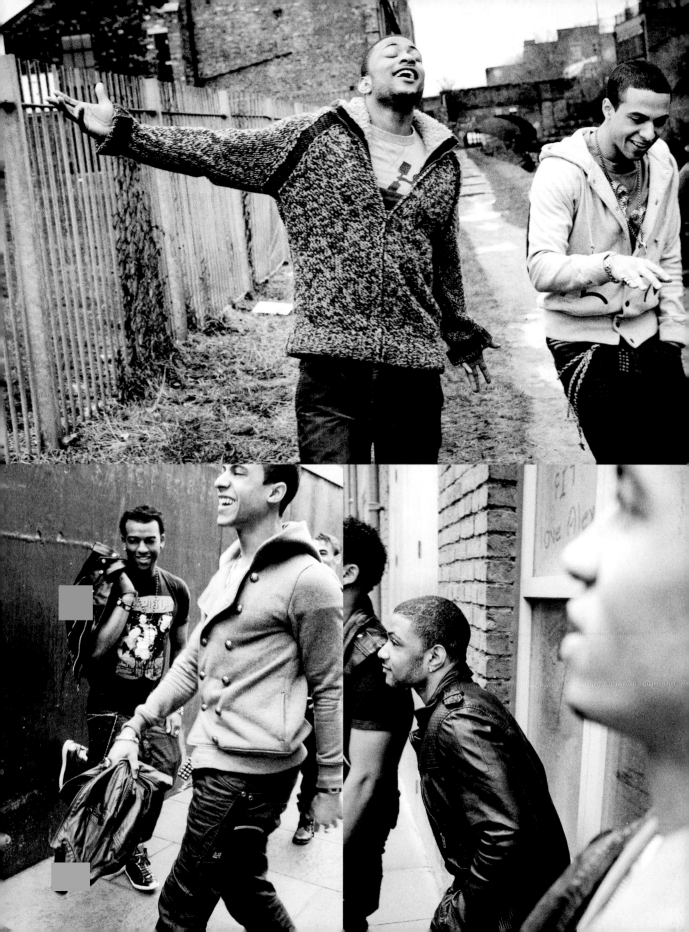

space! Hopefully, we've got at least a year or two to make our mark on the industry.

Eventually I'd love to go into songwriting. I like poetry: one of my favourite poems is Rudyard Kipling's 'If'. The sentiment of the poem is very poignant and relevant to the group, I think. I read a lot. I've got two books on the go at the moment – one about Genghis Khan and the other about the Mafia – and when I'm relaxing, I'll read Jeffrey Archer. Still, I don't do as much reading as I'd like to. But I guess I've got an excuse, because I'm a bit busy right now.

We're determined to have a good time doing what we do, especially when people like Seal say to us, 'Make sure you enjoy it.' The songwriter Wayne Hector said the same thing. Even Gary Barlow says that he wishes he had enjoyed being in Take That more the first time round, so we're trying to learn from other people's experiences.

We're aware that things don't last forever, regardless of how long you want them to last. It gets to a point when you want to be with your family, or you want to slow down because you're getting too old to run about on stage – you want to relax and do your own thing. And when we get to that point, I hope we'll be able to sit down and say that we all really enjoyed ourselves, and didn't let it go to our heads.

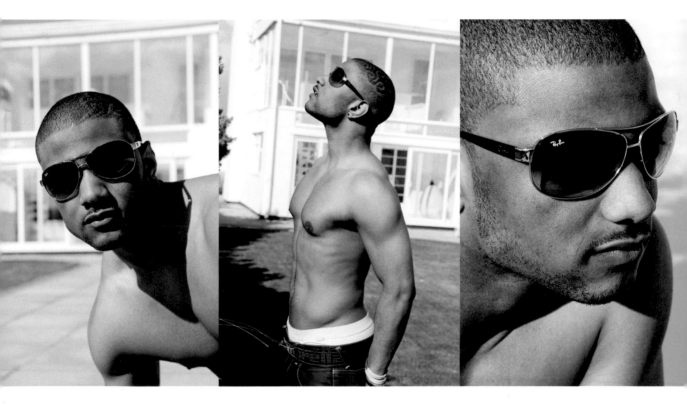

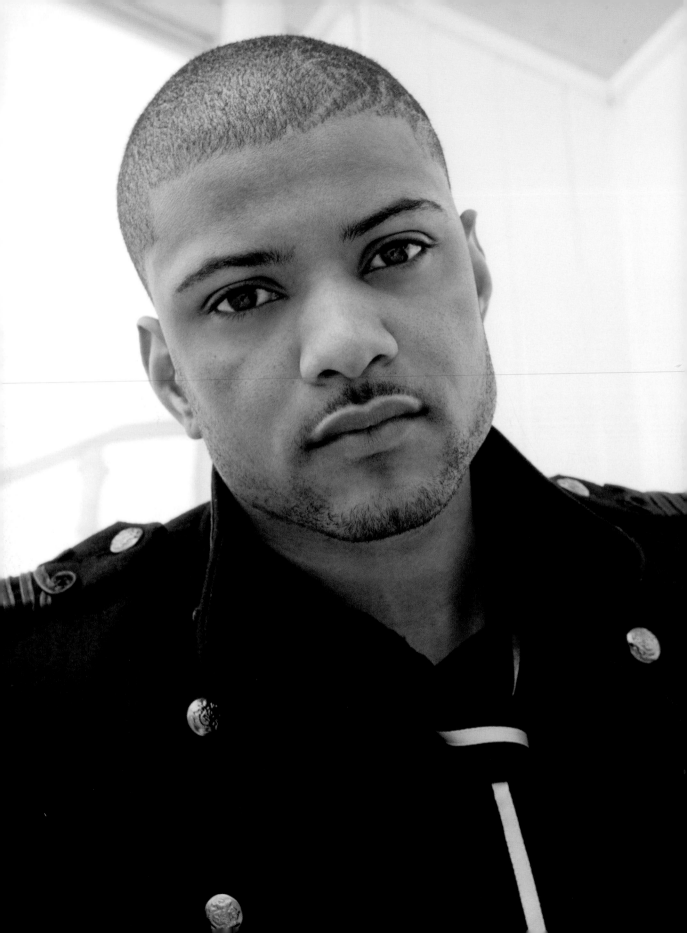

There was a
magic to the way
everything came
together.

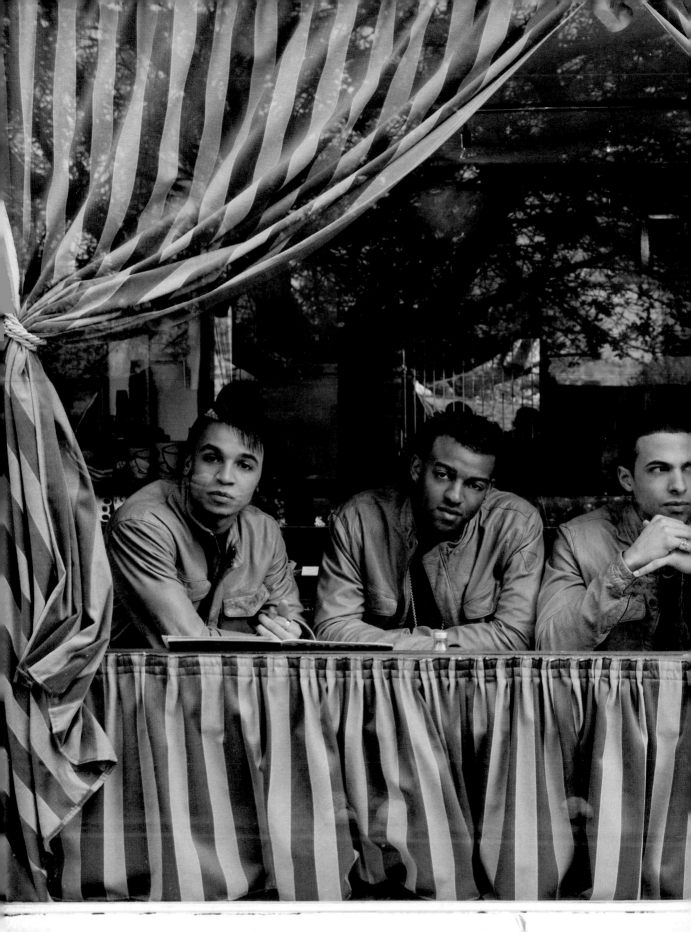

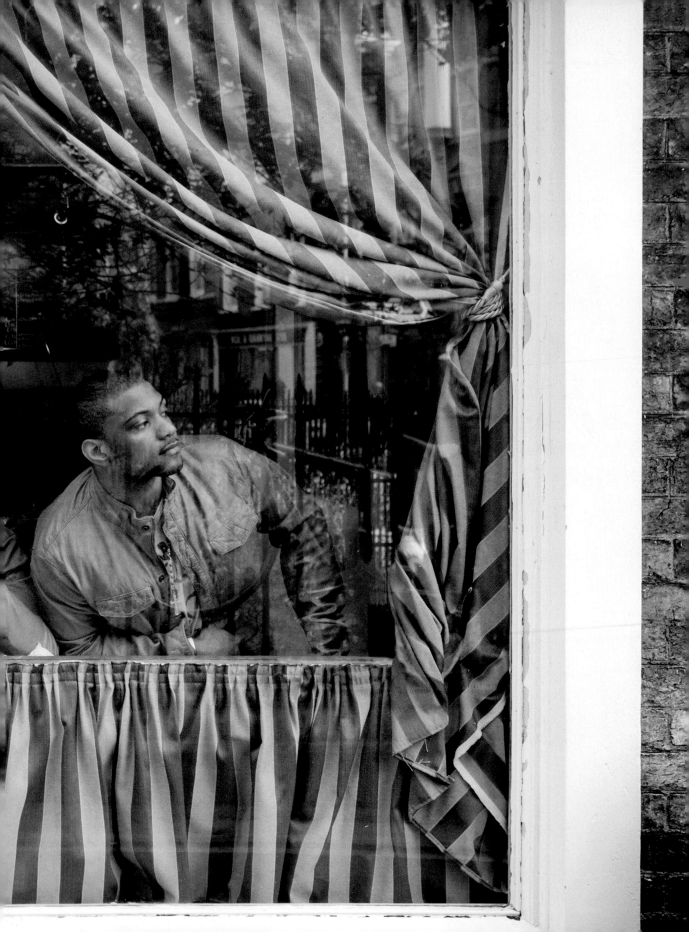

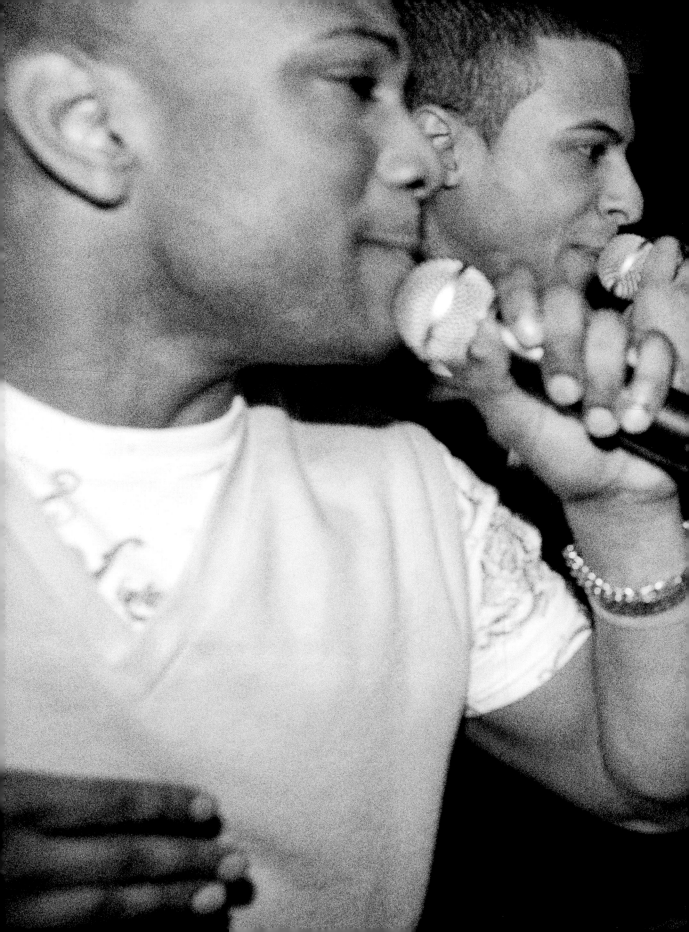

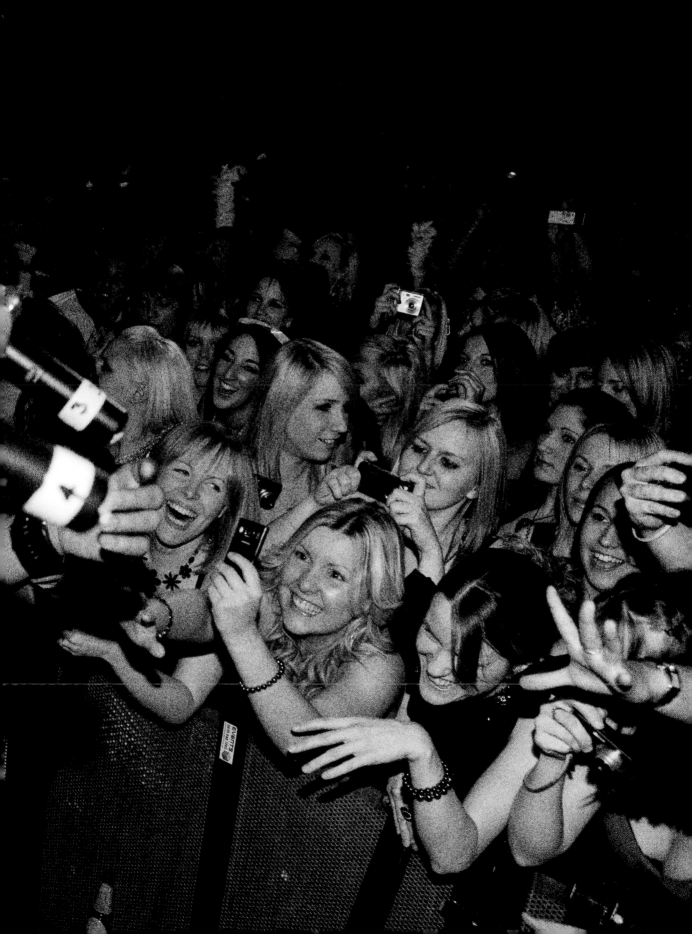

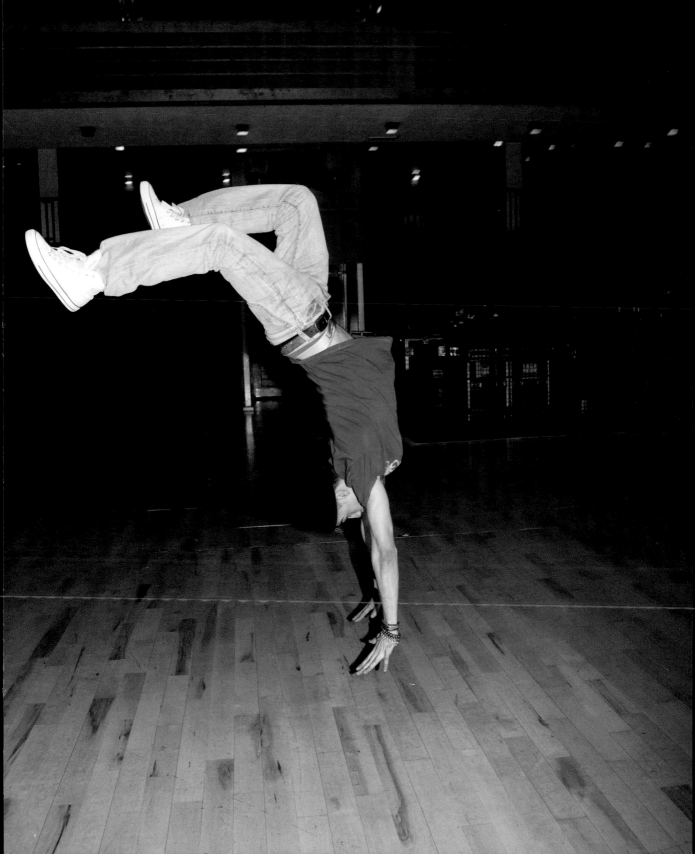

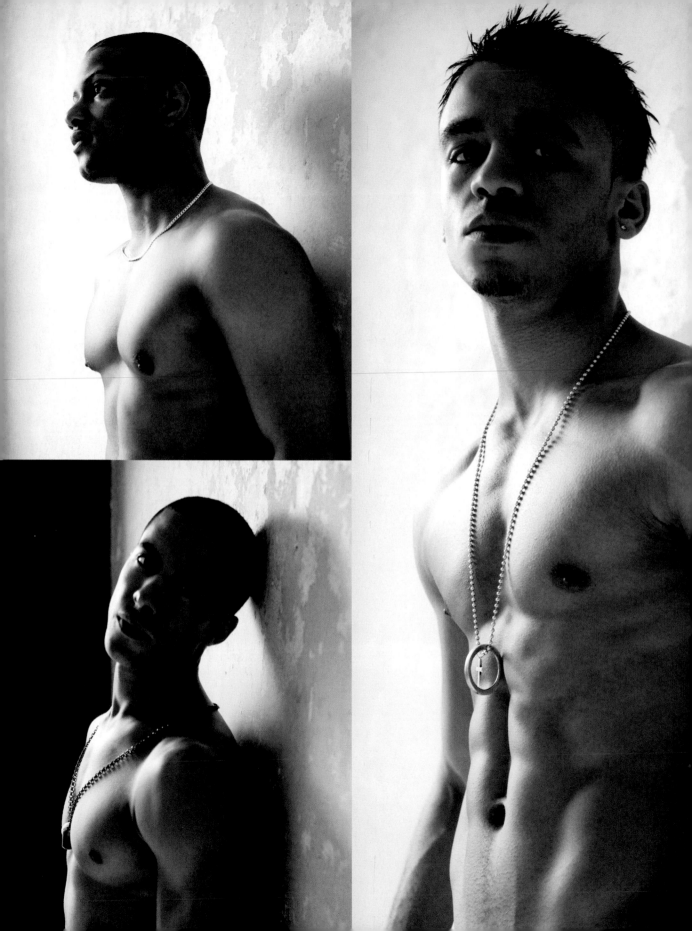

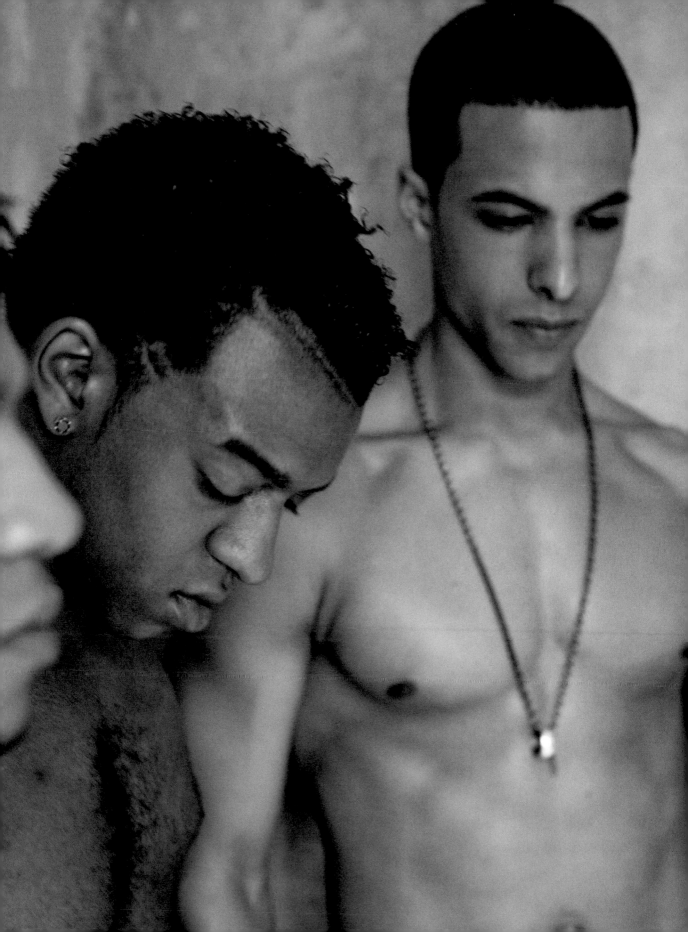

THERE'S NO 'I' IN TE
WAS LOOKING FOR
THE GROUP MENTA
FOUND IN MARVIN,

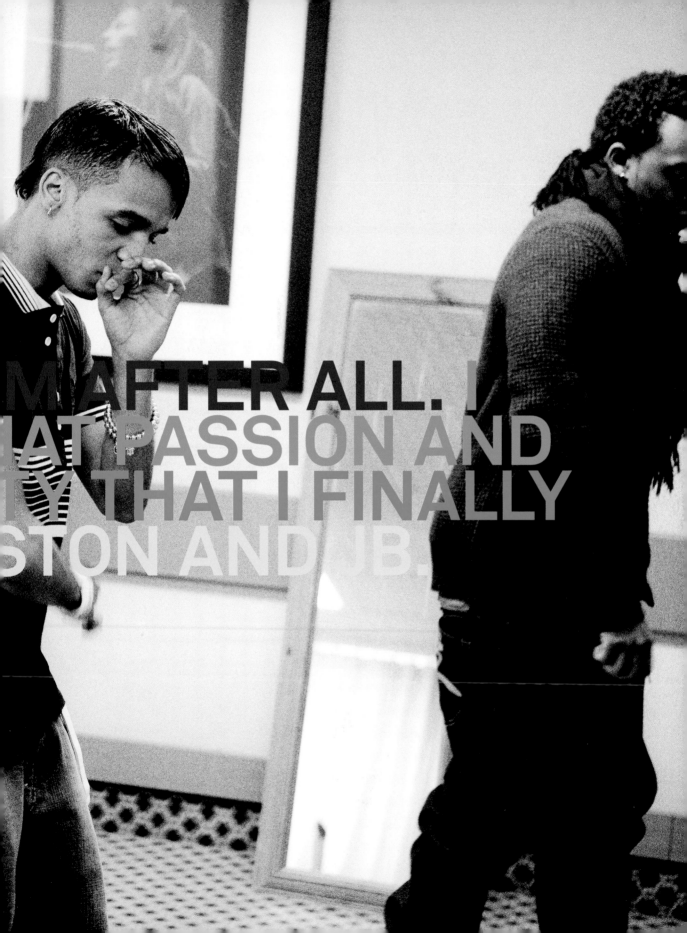

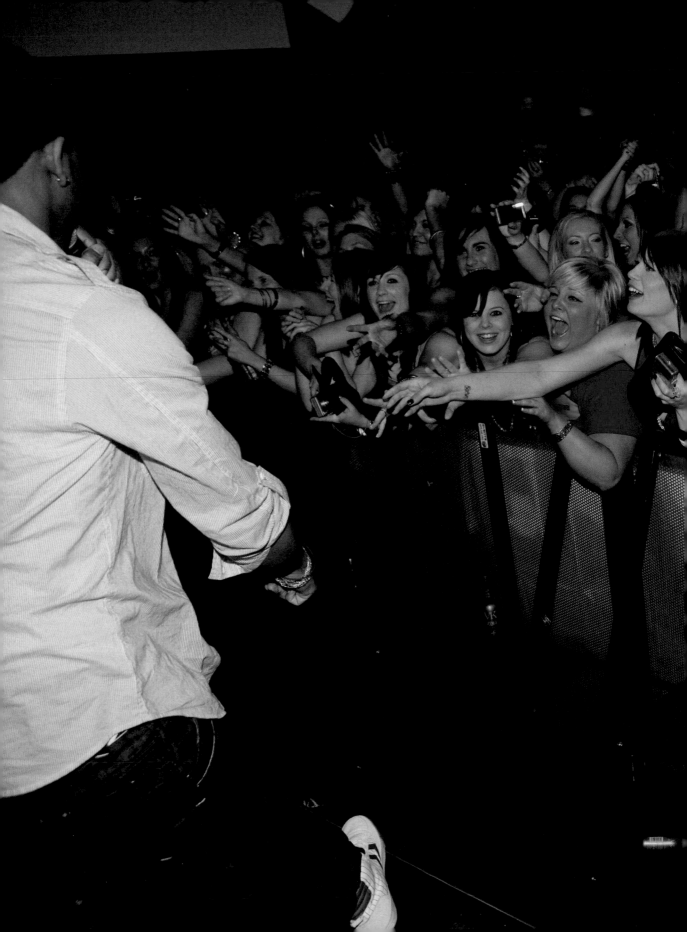

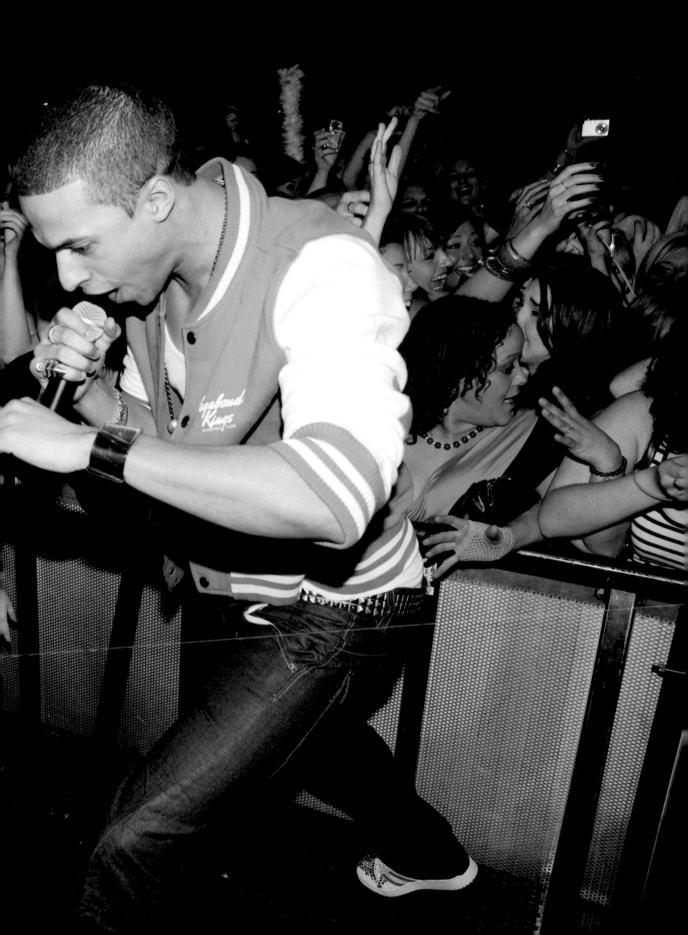

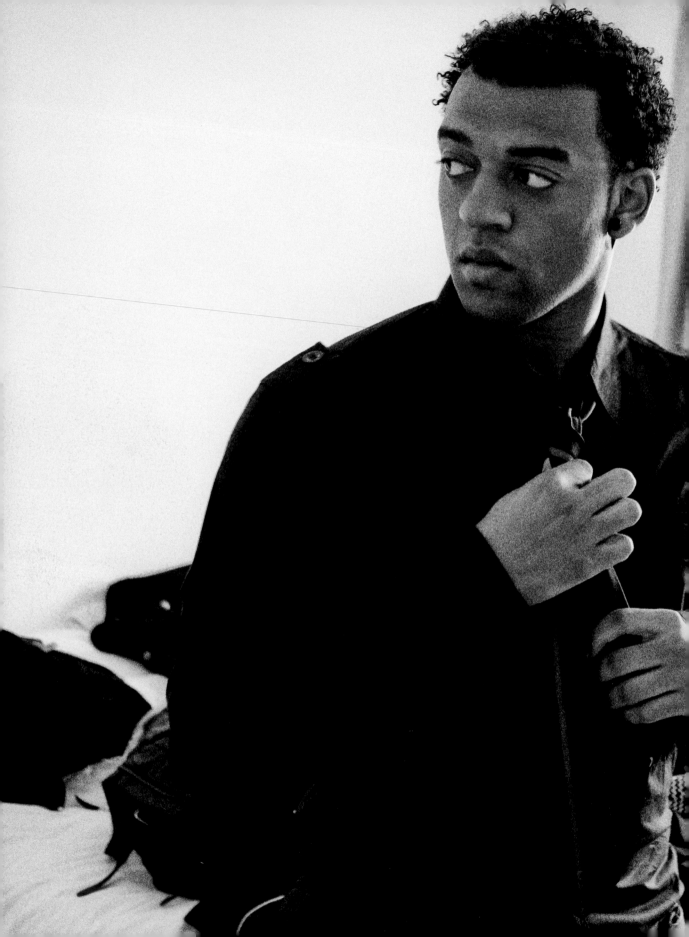

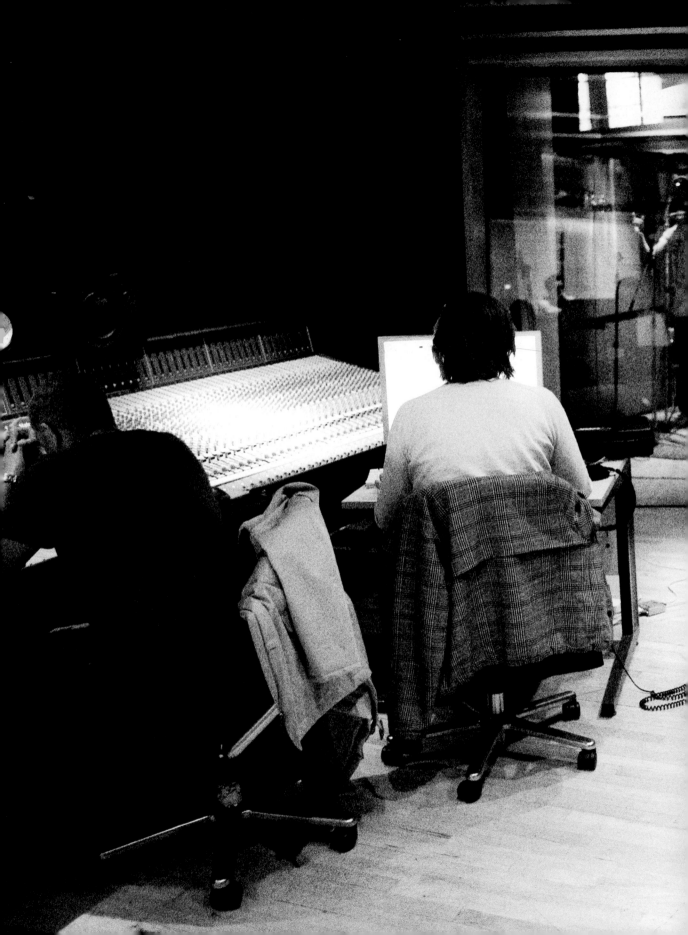

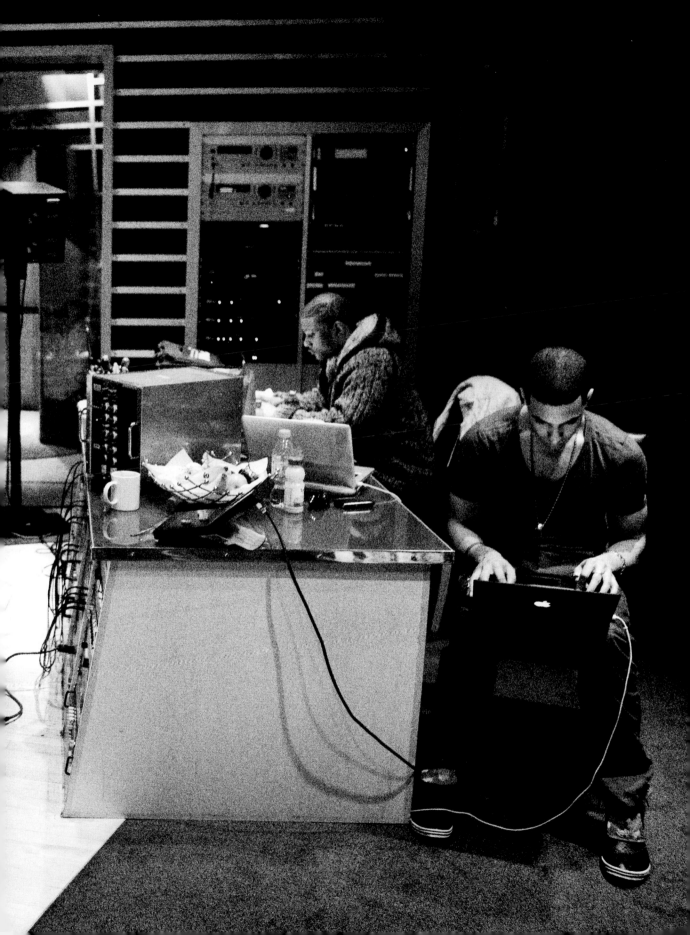

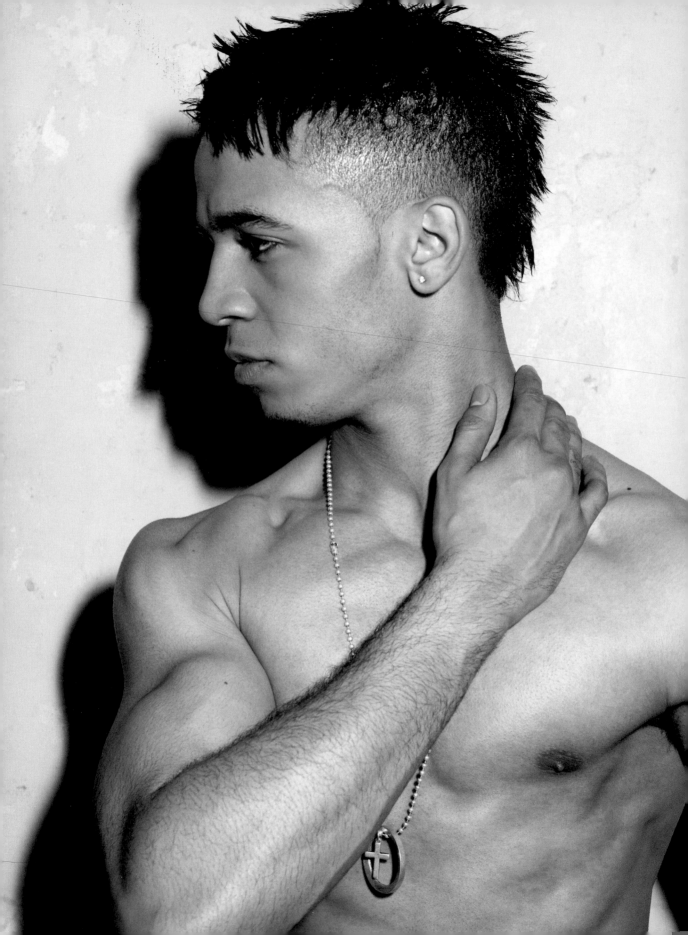

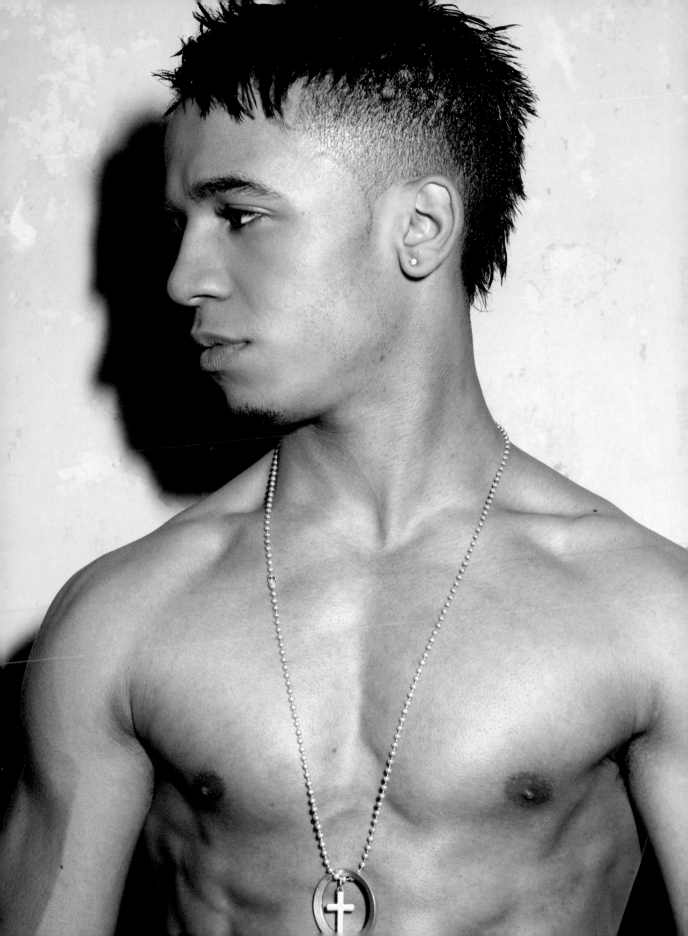

WE'VE GIVEN EVERY
ABSOLUTELY EVERY
WHY WE'RE CONFID
THE FUTURE.

THING TO US
THING. THAT'S
NT ABOUT

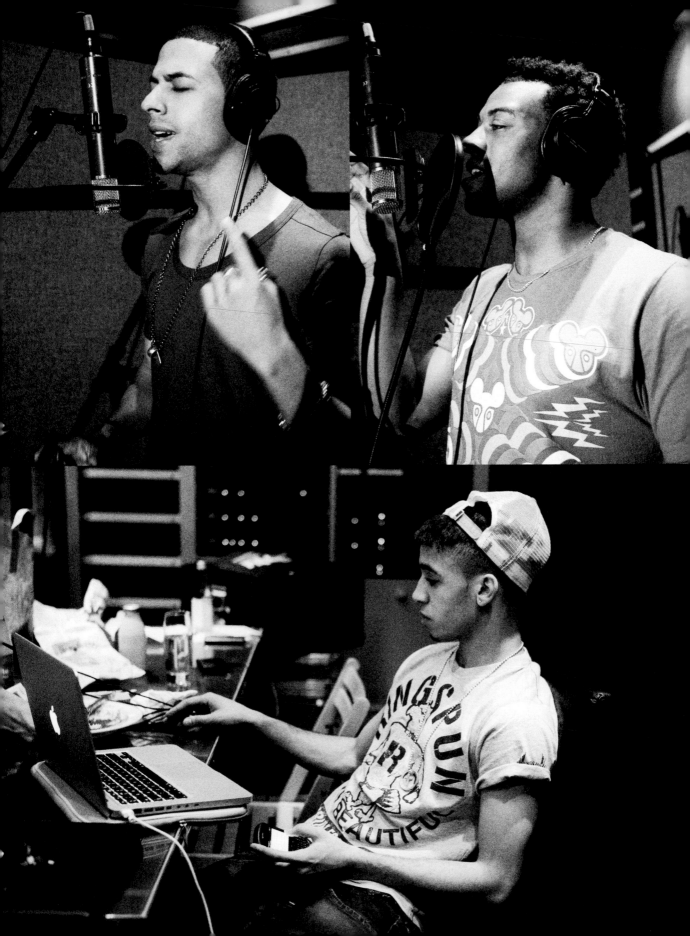

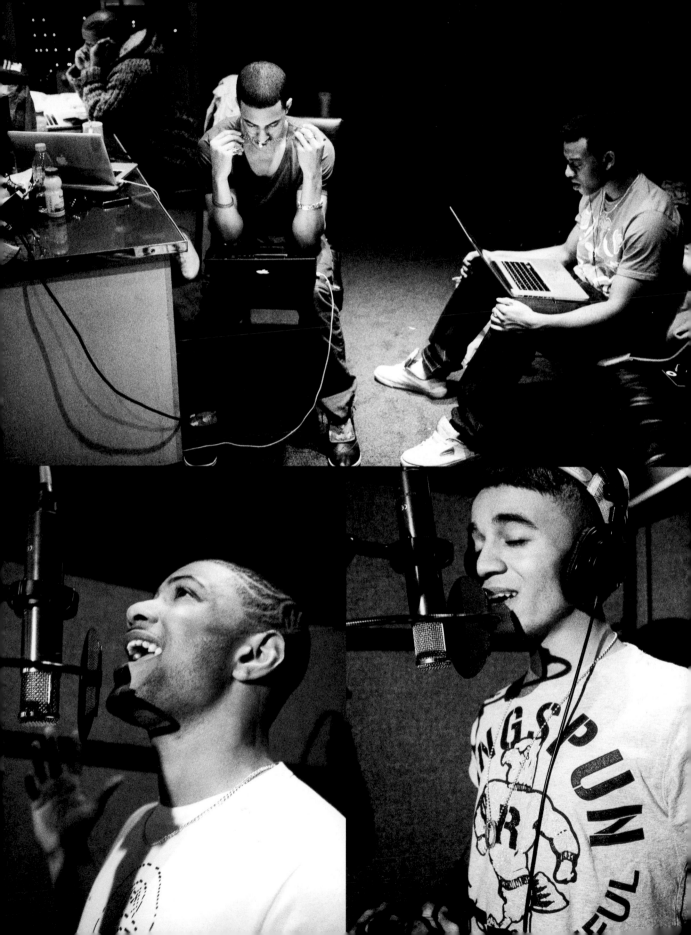

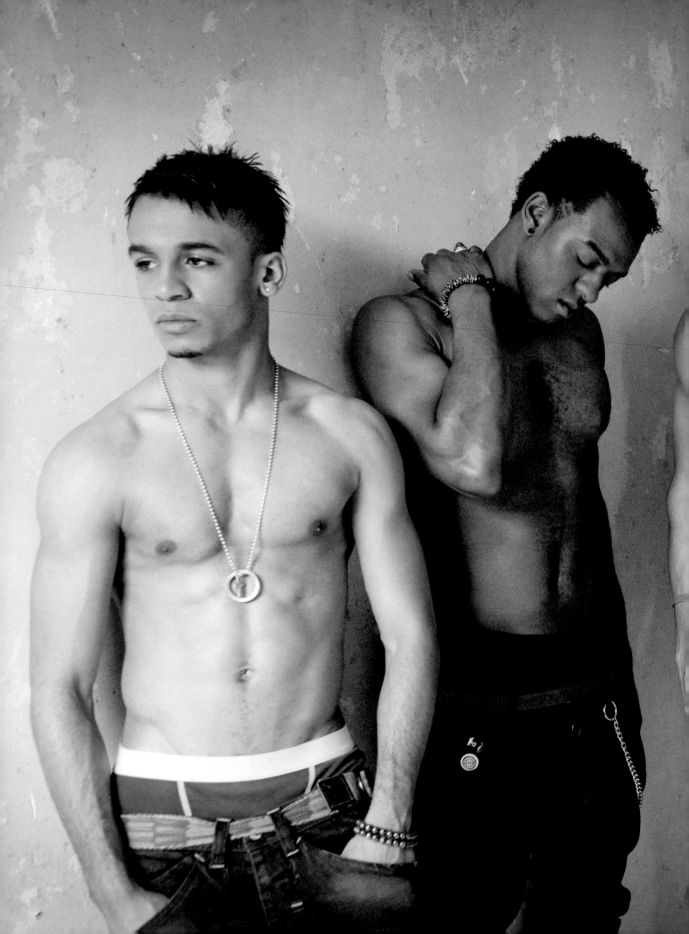

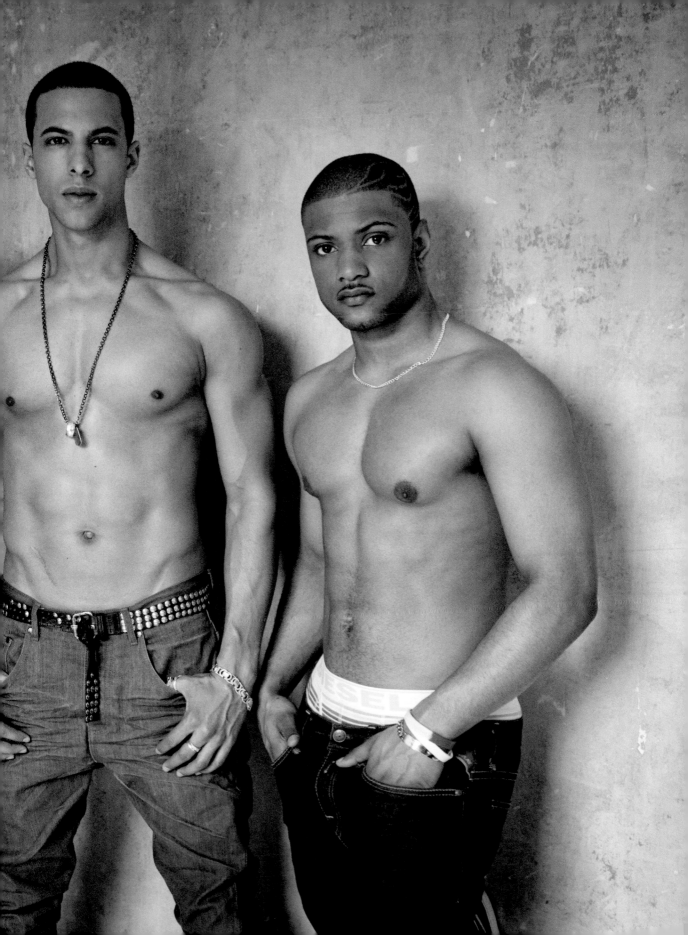

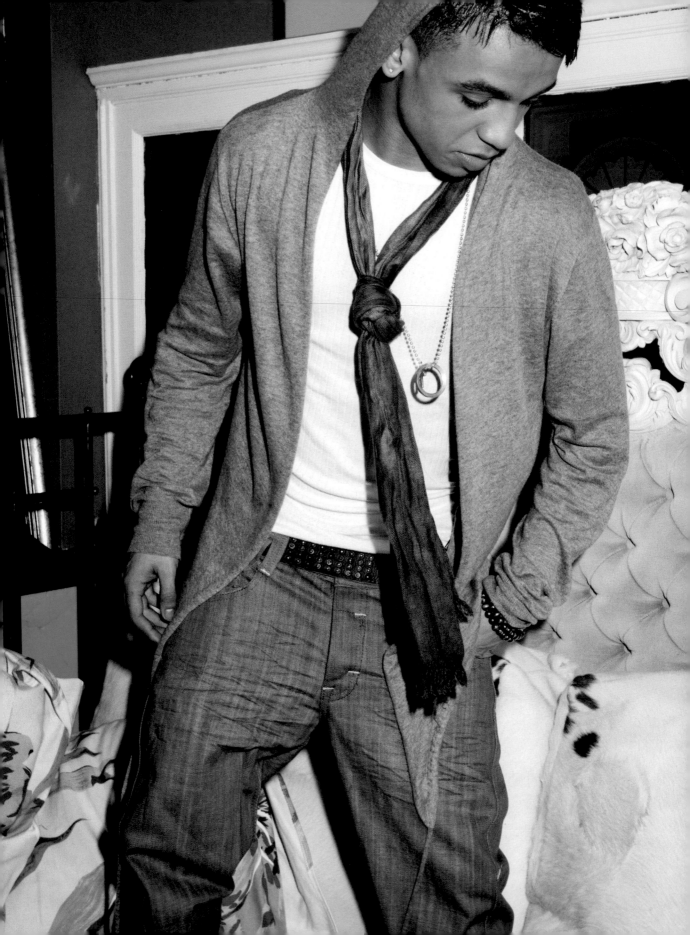

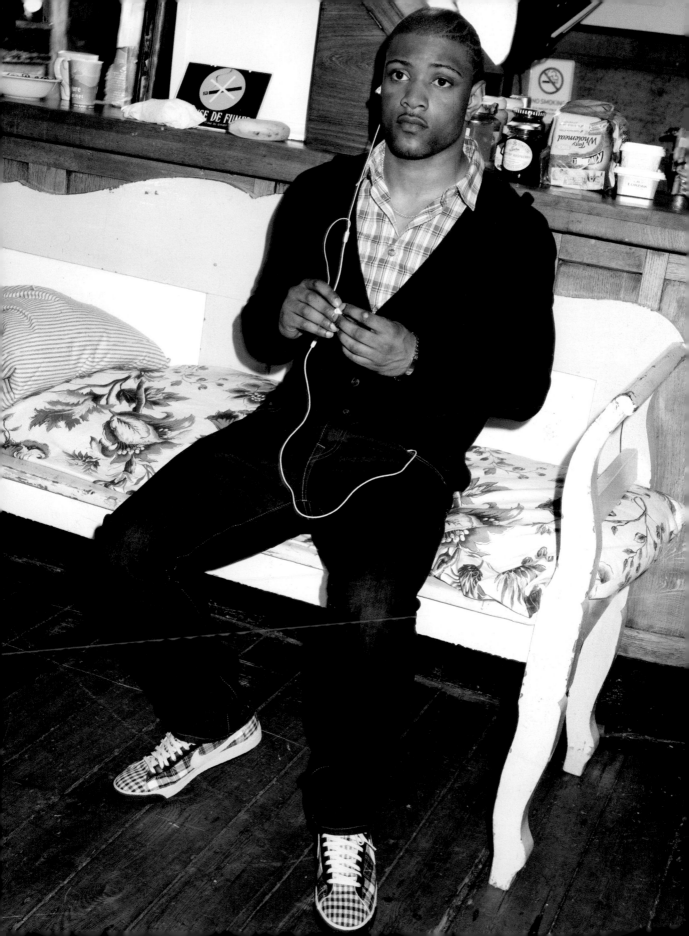

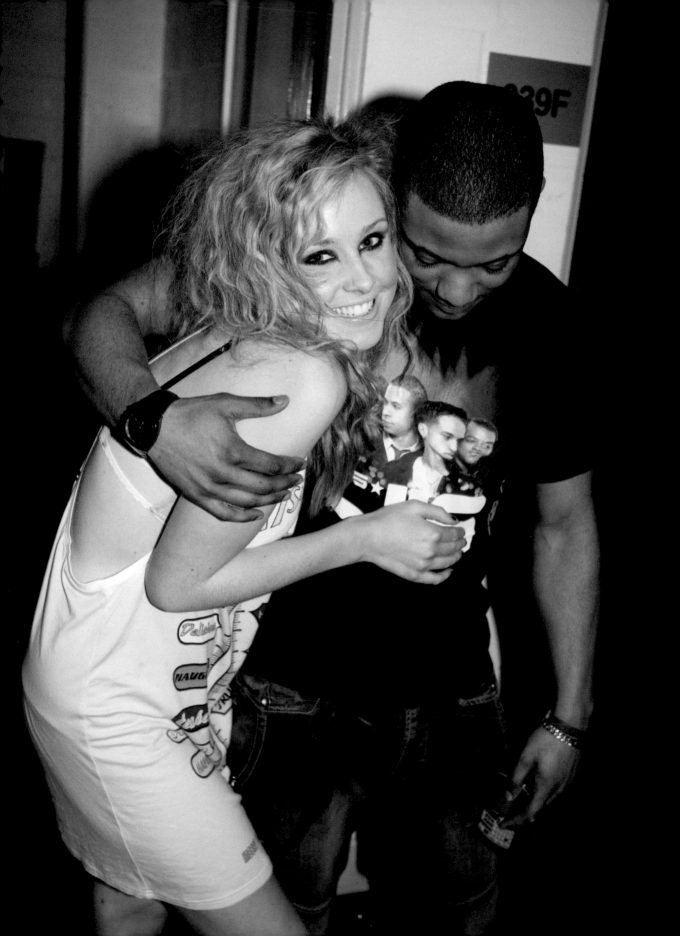

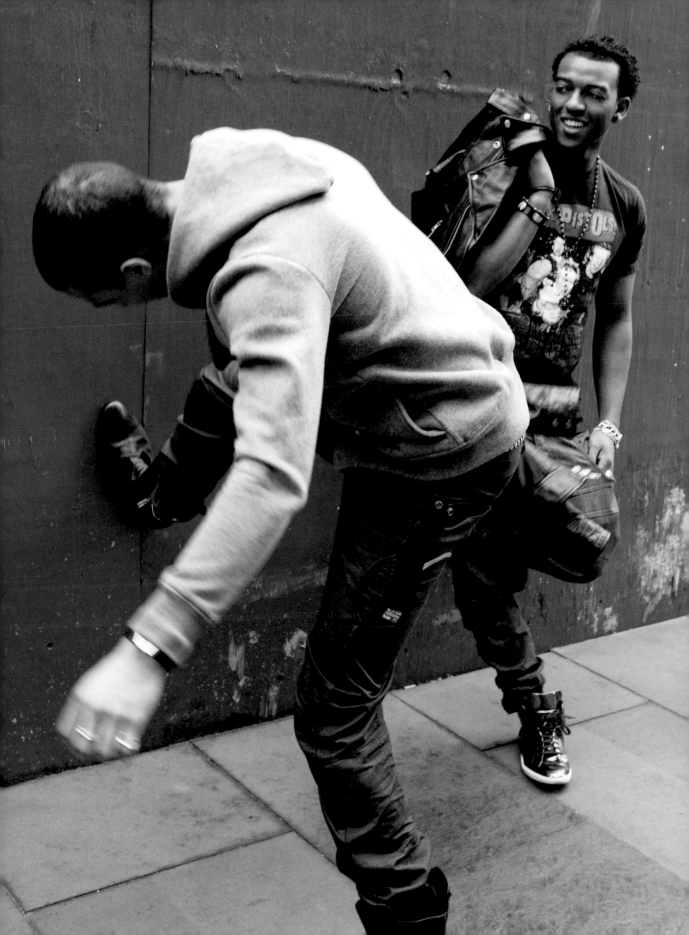

IT'S IMPORTANT TO
FOR THE OPPORTUN
GIVEN. I'M SURE TH
OTHER GUYS WHO A
AS WE ARE. WE'RE
WE'RE THE LUCKY O

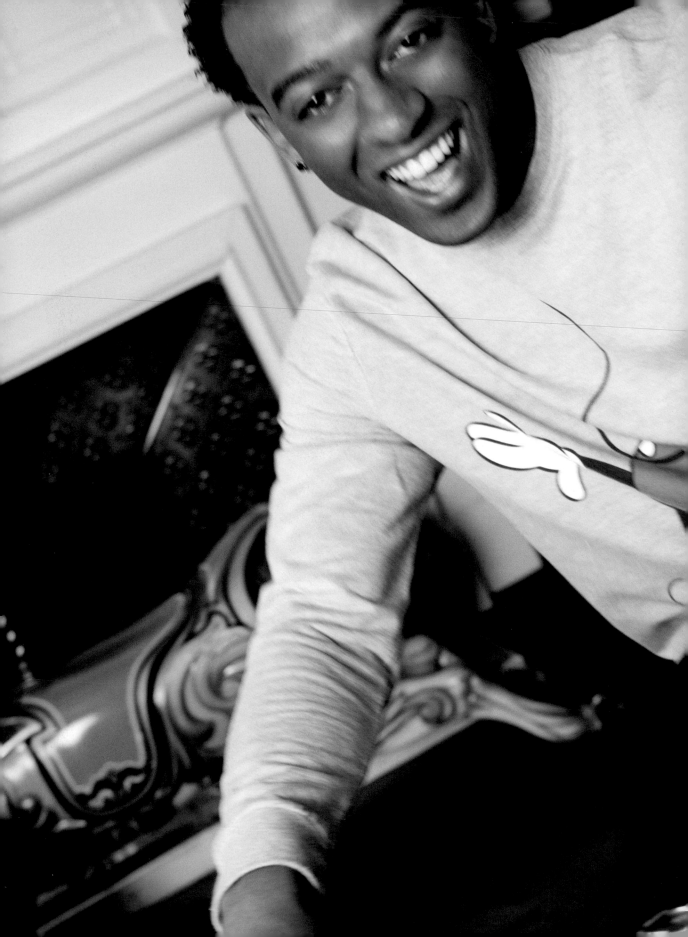

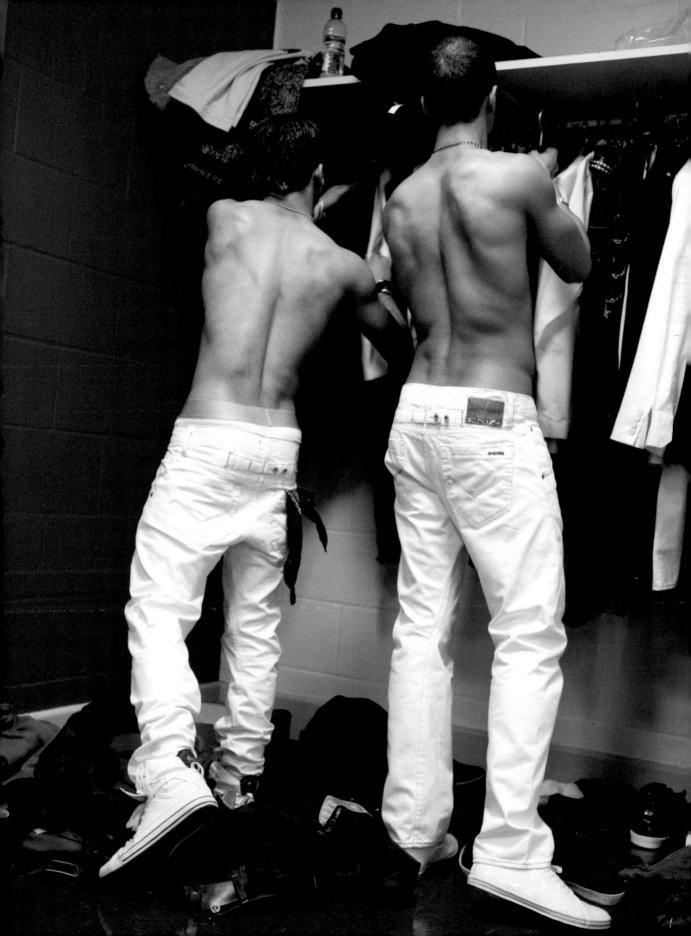

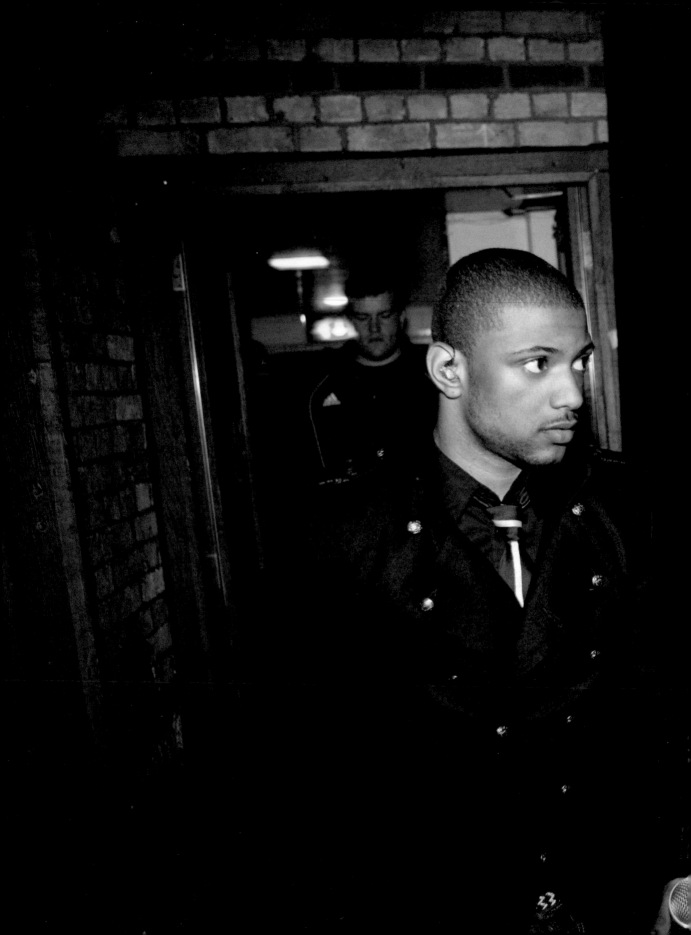

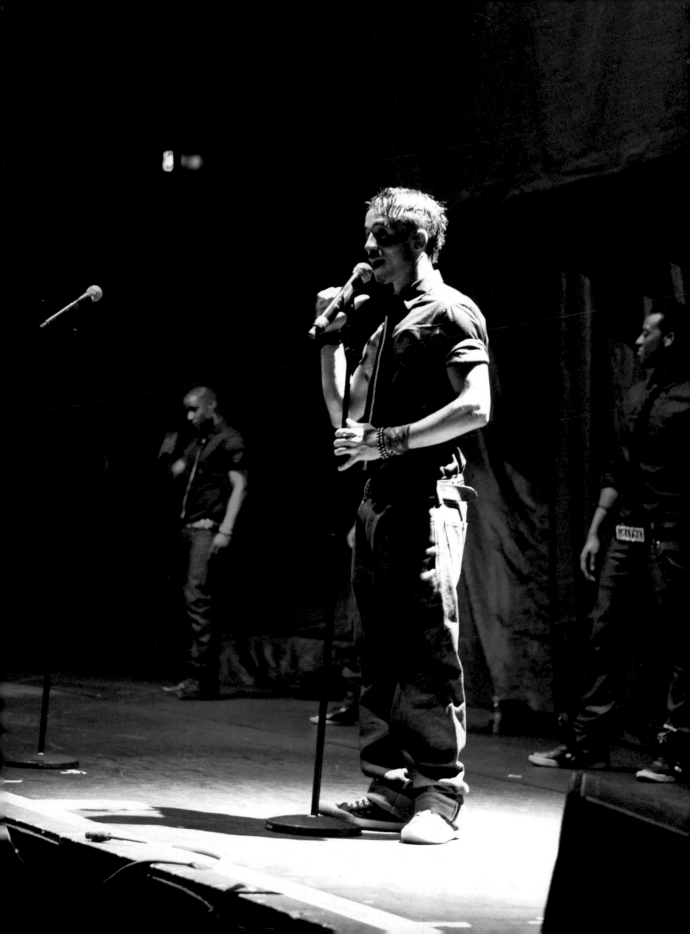

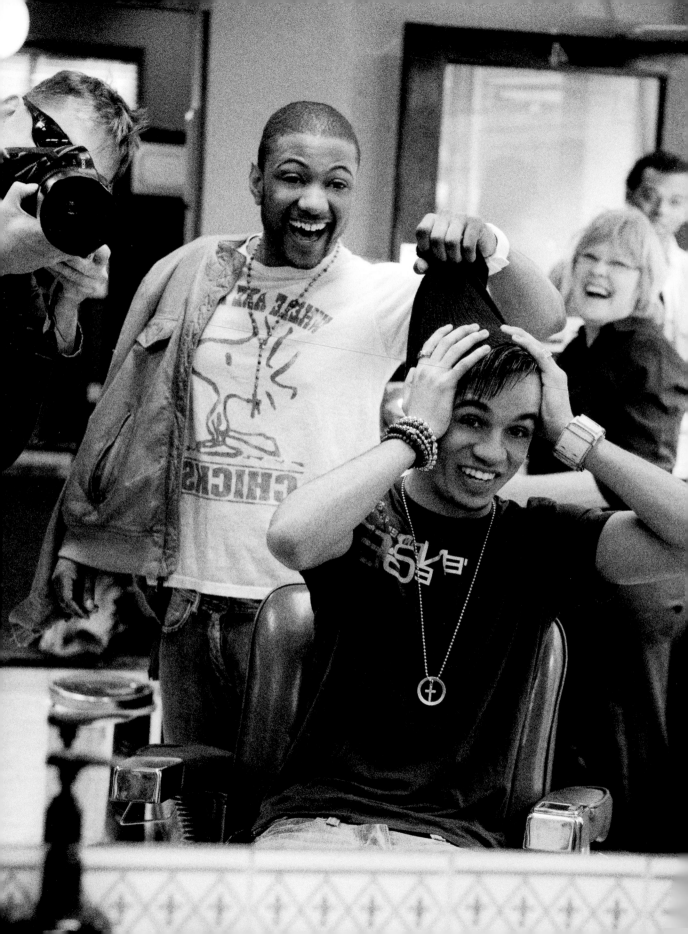

THANKS TO

We would like to thank the HarperCollins NonFiction team for giving us the opportunity to publish our first book! We would particularly like to thank Dean Freeman for his forethought, vision and creativity on this project, Joby Ellis for all the hours he put into the design and layout, and Rebecca Cripps for fine-tuning everything we had to say about our journey so far. We couldn't have done it without you! To Richard Griffiths, Harry Magee, Phil McCaughan, Pino Pumilia and the rest of the Modest! Management team, thank you for being so influential in the production of this book. We cannot forget to thank Alexi Cory-Smith, Mark Ashleford and all those at Lee and Thompson solicitors for helping us to handle the legal side of this publication. A big thank you must also go to Lucy, Ellie, Michael and Michael for making our clothes, faces and hair look fantastic at all times! We love you guys! Thanks to Sony Music/Epic Records who have given us the musical platform to make this book possible and to our avid supporters, we love each and every one of you. In truth, without you none of this would have even been remotely possible. Finally, to all of our families, thank you all for continuing to be the extensive support structure behind our musical journey. We love you.

ORITSÉ

I firstly want to thank my mother, Sonia, who is an irreplaceable inspiration in my life. My sister Naomi and brothers Temi & Evan, who keep me motivated in all that I do. I would like to thank Modest! Management for believing so much in everything that JLS does, particularly our day-to-day manager Phil McCaughan who shares the same passion and visions we do. I would like to thank Rebecca Cripps for helping us let go and reveal all our deepest, darkest secrets haha. Dean Freeman and assistant Gem, for producing the most incredible, iconic photographic images. Finally I have to personally thank and extend all my devoted love and gratitude to our beloved JLS fans who have bought this book and are reading it right this minute and who support JLS through it all.
I LOVE YOU!

MARVIN

I would like to dedicate this book to each and every person reading this that has supported JLS on our amazing journey so far. I know it's a cliché, but we truly wouldn't be writing this book if it wasn't for you and everyone who voted for us on *The X Factor*, so with this I humbly, gratefully and sincerely thank you all from the bottom of my heart. This is only the beginning. I love you all very much, thank you for all your support, we will do you proud!

I would also like to dedicate this book to my nan, Patricia Hughes, who I love and treasure dearly and whose strength and courage has been an inspiration to me. I love you so much Nan x

ASTON

I would like to take this opportunity to thank every single person who has ever helped, supported or taken an interest in me and this amazing group I am blessed to be a part of! I would also like to thank these three guys who have made this book possible for me by becoming part of my family! x

JB

Firstly I would like to thank my mother, father and brother, who could not have prepared me any better for being part of such an amazing journey. To the Gill and George family & friends, thank you all for your continued support. To Richard, Harry, Phil and all who have been part of the JLS/Modest! Management relationship, thank you for your belief in the JLS movement. To Epic records, thank you for being the vehicle through which we can achieve all of our dreams. Lastly but by no means least, I would like to thank God for giving JLS the strength to work hard, the courage to persevere and the determination to succeed.

DEAN FREEMAN

I would like to thank the JLS boys for their energy, professionalism, talent and manners. Your enthusiasm and determination is truly admirable and I wish you all the best for a long and stable life in music. To Modest! Management, Harry Magee, Richard and Phil – great team. Alexi Cory-Smith, Mark Ashelford, Rebecca Cripps, Joby Ellis, Jeremy Rigby, Richard Poulton and special thanks to Natalie Jerome and all at HC.

IT DOESN'T STOP HERE...
WATCH EXCLUSIVE JLS VIDEO CONTENT!

You've come to the end of their story so far, but now you can watch an exclusive video too.

See Oritsé, Marvin, Aston and JB in action during the production of the book; on photo shoots, in the recording studio and much more. This is never-before-seen, behind the scenes footage, which is available exclusively to you!

To watch the video of JLS, simply peel the sticker off the front of this book to reveal your own personal access code. Then visit **www.jlsbook.com** where you can enter your code enabling you to view this exclusive, never-before-seen footage.

HarperCollins*Publishers*
77–85 Fulham Palace Road,
Hammersmith, London W6 8JB
www.harpercollins.co.uk

First published by HarperCollins*Publishers* 2009

10 9 8 7 6 5 4 3 2 1

© JLS 2009

Creative direction/photography/original book
concept by Dean Freeman
Designed by Joby Ellis
DVD footage by Cassius Freeman

Photographs © Dean Freeman with exception of
p. 16, 33, 42 © Oritsé Williams
p. 66, 70, 78 © Marvin Humes
p. 107, 128, 133 © Aston Merrygold
p. 150, 162, 170 © Jonathan Gill

Marvin Humes, Jonathan Gill, Oritsé Williams, Aston Merrygold assert the
moral right to be identified as the authors of this work

A catalogue record of this book is
available from the British Library

ISBN 978-0-00-732863-5

Printed and bound in Great Britain by
Butler Tanner and Dennis, Frome, Somerset

Mixed Sources
Product group from well-managed
forests and other controlled sources
www.fsc.org Cert no. SW-COC-1806
© 1996 Forest Stewardship Council

FSC is a non-profit international organisation established to promote the
responsible management of the world's forests. Products carrying the FSC
label are independently certified to assure consumers that they come
from forests that are managed to meet the social, economic and
ecological needs of present and future generations.

Find out more about HarperCollins and the environment at
www.harpercollins.co.uk/green

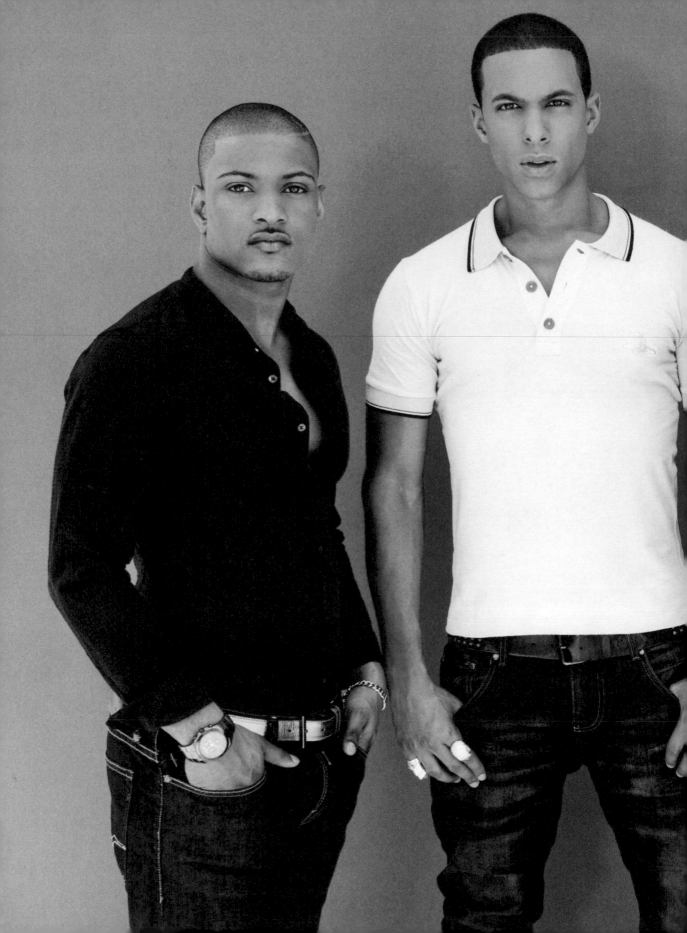